CONCEPTUAL ART

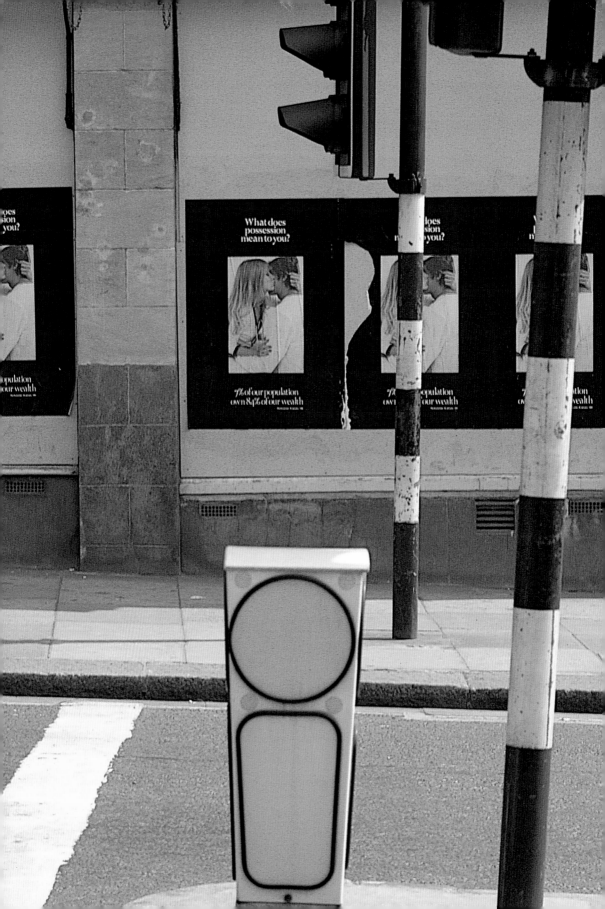

CONCEPTUAL ART

PAUL WOOD

TATE PUBLISHING

Cover:
Keith Arnatt
*Self-Burial (Television
Interference Project)*
1969
(detail of fig.29)

Frontispiece:
Victor Burgin
Possession 1976
(detail of fig.54)

ISBN 1 85437 385 4

A catalogue record
for this book is
available from the
British Library

Published by order
of Tate Trustees
by Tate Publishing,
a division of Tate
Enterprises Ltd
Millbank, London
SW1P 4RG

Cover designed by
Slatter-Anderson,
London.
Book designed by
Isambard Thomas.
Printed in Hong
Kong by South Sea
International
Press Ltd.

Measurements
are given in
centimetres,
height before width,
followed by inches
in brackets.

For Peter and Kevin

Contents

I

APPROACHING CONCEPTUAL ART

As befits an art of the mind, 'Conceptual art' poses problems right from the start. What was it? When was it? (Is it still around or is it 'history'?) Where was it? Who made it? (Are we to consider 'X' a Conceptual artist or not?) And of course, the umbrella-question: why? Why produce a form of visual art premised on undercutting the two principal characteristics of art as it has come down to us in Western culture, namely the production of objects to look at, and the act of contemplative looking itself (fig.1)?

This is not just a rhetorical device with which to open a book on the subject. These are real questions. It is not at all clear where the boundaries of 'Conceptual art' are to be drawn, which artists and which works to include. Looked at in one way, Conceptual art gets to be like Lewis Carroll's Cheshire cat, dissolving away until nothing is left but a grin: a handful of works made over a few short years by a small number of artists, the most important of whom soon went on to do other things. Then again, regarded under a different aspect, Conceptual art can seem like nothing less than the hinge around which the past turned into the present: the modernist past of painting as *the* fine art, the canon from Cézanne to Rothko, versus the postmodernist present where contemporary exhibition spaces are full of anything and everything, from sharks to photographs, piles of rubbish to multi-screen videos – full, it seems, of everything except modernist painting.

Moreover, Conceptual art's legacy is exceptionally argumentative. Most of the major players are still living, and matters of status and priority are jealously guarded. In the mid-1990s, members and ex-members of the English group Art & Language conducted a war of words in print about the history of their

activities in the mid-1970s. In the 1989 catalogue to *L'art conceptuel* at the Centre Pompidou in Paris, the first major exhibition to survey Conceptual art as a historical phenomenon, the artist Joseph Kosuth accused the historian Benjamin Buchloh of partisanship and bias after Buchloh had accused *him* of falsifying his role in the movement's origins. And this is not a new phenomenon. As early as 1973, the American artist Mel Bochner greeted the critic Lucy Lippard's attempt to catalogue developments in Conceptual art from 1966 to 1972 in her book *Six Years*, with a root and branch condemnation in the pages of *Artforum*, the leading art magazine of the period. For Bochner, Lippard's account was 'confusing' and 'arbitrary', an 'act of bad faith' that resulted in little more than a 'parody' of what actually happened. Much later, in the 1990s, when 'historical' Conceptual art began to be curated on a major scale, Lippard herself set her sights on those who now queued up to explain its importance, writing that she trusted neither the memories of those who were there, nor the supposedly authoritative overviews of historians who weren't. In addition to such disputes, the historical accounts of Conceptual art that have emerged scarcely offer a consensus. Lippard's retrospect chronicled a set of efforts, not least by women and Latin American artists, to break free of the bureaucratic and confining protocols of modernism, itself held to be largely client to the wider structures of American power. The critic and historian Charles Harrison regards Conceptual art, particularly the work of the Art & Language group, not as a break with modernist principles in the name of a re-engagement with social modernity, but as a necessary re-formulation of the grounds of art's critical independence. For him, an engagement with social modernity and aesthetic independence are anything but antithetical. For his part, Benjamin Buchloh judged the work of at least some of Conceptual art's leading practitioners to be nothing less than 'an aesthetic of administration', that is, as mirroring the structures of Western capitalism in its managerial, post-industrial phase; for Buchloh, the only defensible 'conceptualist' practice was a critique of cultural institutions. In the face of such contrasting views it would be naïve to assume that the present book has located the Archimedean point from which a fully finished account of Conceptual art may be levered into the edifice of art history.

NAMES

Even the name presents something of a problem. I have already used the phrase 'Conceptual art' to refer to a historical form of avant-garde practice that flourished in the late 1960s and 1970s. The term had historical currency, being used at the time to refer to a variety of language-, photography- and process-based activities: a kind of fall-out from the collision of Minimal art and various 'anti-formal' practices on the one hand with the institution of Modernism on the other, in a climate of increasing cultural and political radicalism. The American artist Sol LeWitt published his 'Paragraphs on Conceptual Art' in 1967 and subsequently his 'Sentences on Conceptual Art' in 1969. Also in 1969, the first issue of the periodical *Art-Language* featured on its cover the sub-heading, 'The Journal of Conceptual Art'. But the phrase 'Concept art' turns out to have been first employed by the writer and musician

Henry Flynt as early as 1961 in the context of activities associated with the Fluxus group in New York. In an essay subsequently published in the Fluxus *Anthology* (1963), Flynt wrote that '"Concept Art" is first of all an art of which the material is "concepts"', going on to make the point that, 'since "concepts" are closely bound up with language, concept art is a kind of art of which the material is language'. Yet, as central a figure as Lucy Lippard has commented flatly that Flynt's Fluxus-inspired sense of 'Concept Art' had little to do with what she understood as the key activities of the Conceptual art vanguard in New York in the mid- to late-1960s: 'few of the artists with whom I was

mean·ing (mēn′iŋ), *n.* 1. what is meant; what is intended to be, or in fact is, signified, indicated, referred to, or understood: signification, purport, import, sense, or significance: as, the *meaning* of a word. 2. [Archaic], intention; purpose. *adj.* 1. that has meaning; significant; expressive.

1
Joseph Kosuth

Titled (Art as Idea as Idea) [Meaning] 1967

Photostat on paper mounted on wood
119.4 x 119.4
(47 x 47)
The Menil Collection, Houston

involved knew about it, and in any case it was a different kind of "concept"'. The point here is *not* that a discussion of antecedents should be excluded from a study of Conceptual art, but that, in writing histories of art, we have to be wary of making plausible-sounding art historical connections that may have had less impact on the actual making of art at the time than retrospective genealogists would like.

It is with such issues in mind that we have to be aware of a third term that has come into increasing currency. The term is 'conceptualism', and it has more than one inflection. On the one hand, there is a use of this word favoured by

journalism. To take an example more or less at random, in the run-up to the 2000 Turner Prize competition at Tate Britain in London, one of the English broadsheet (not tabloid) newspapers casually aimed a jibe at 'the dead animal/unmade bed conceptualism' of contemporary art. 'Conceptualism', that is, has come to stand in some quarters for the array of contemporary practices that do not conform to conventional expectations of art exhibitions showing hand-crafted objects for aesthetic contemplation. In this sense, 'Conceptualism' becomes a negative catch-all for what conservatives of various stripes do not like about contemporary art.

There also exists however, a diametrically opposed sense of the term. It has become a commonplace of the politically correct that modernism was the art of the West, in particular of North America and Western Europe, and an art of men from those places, to boot. Insofar as Conceptual art appears to stand at a transitional point between high modernism and what followed, there have been attempts to broaden the range of 'Conceptual art' out beyond the Anglo-American centre-ground where it was mainly established during the approximate decade 1965–75. A recent collection of essays, titled *Rewriting Conceptual Art* has it that such art constitutes the ground 'on which nearly all contemporary art exists', and that in its recent efflorescence, 'Conceptualism has become all-pervasive if not dominant in the art world'. From that perspective, 'conceptualism' takes on a double identity. 'Analytical' Conceptual art gets downgraded as the art of white male rationalists, mired in the very modernism they sought to critique. The expanded history, on the other hand, begins to excavate a huge array of artists, men and women alike, deemed to have been working in a 'conceptualist' manner from the 1950s onwards, on a range of emancipatory themes ranging from imperialism to personal identity in far-flung places from Latin America to Japan, from Aboriginal Australia to Russia. The result is a claim for 'Global conceptualism', the title of a major exhibition in New York in 1999.

One of the tasks of the present introduction to Conceptual art, then, is to hold apart these rival senses of the central term: neither embracing as unproblematic the full-scale 'conceptualist' hypothesis, nor restricting attention to an Anglo-American (and now historical) Conceptual 'canon'; neither regarding Conceptual art as engaged postmodernism *avant la lettre*, nor as a fading, bureaucratic echo of modernism. We will pay most attention to various tendencies that were significant in the crucial decade from the mid-1960s to the mid-1970s. But before that we need to look at where Conceptual art came from, its 'pre-history', so to speak. And finally we need briefly to consider the question of its legacy for contemporary art: the question of whether Conceptual art did indeed pave the way for an internationally successful 'conceptualism'.

2
Kazimir Malevich

Black Square 1915

Oil on canvas
80 x 80 (31½ x 31½)
Tretyakov Gallery,
Moscow

PRECONDITIONS AND PERSPECTIVES

The relationship between Conceptual art and modernism is a fraught issue. What we can say with some certainty is that modernism in the dominant form it had come to take in the Anglo-American world at least, that is to say as theorised by the critic Clement Greenberg and frequently dignified with a capital 'M', went into deep, arguably terminal, crisis in the late 1960s. This was a spectacular fall. But it was not the first. The modern movement underwent an earlier crisis, from which it recovered, and from which modernism in the so-called 'Greenbergian' sense emerged to become dominant. We need to establish a view of this M/modernism, the better to comprehend Conceptual art's challenge to it. In doing so, we also need to encounter early modernism's 'other': the historical avant-garde (a distinction I owe to the German historian Peter Bürger).

FORM

Early modernism was transcultural and transhistorical in its sweep. The Bloomsbury critics Clive Bell and Roger Fry famously isolated the essential feature of art as 'form': 'significant form' for Bell, 'expressive form' for Fry. For Bell and Fry and others, modern art as it had been established by Cézanne held out the promise of escaping from the weight of academic tradition through this emphasis on pictorial form. This, it was claimed, could affect the emotions of the sensitive spectator in a way comparable to the effects of sound in music; that is, independently of what the forms may happen to depict. It is easy to see how this kind of thinking coincided with practical moves towards a fully abstract

art; an art 'purified' of narrative or descriptive features, and acting on the spectator like a 'visual music'. The work that, in retrospect, seems to have declared open the world of abstract art, like a kind of visual manifesto, was Kasimir Malevich's *Black Square*, exhibited in Petrograd in December 1915 (fig.2). Both Malevich and Mondrian had seized on the opening made by Cubism and, from first encounters with it around 1911/12 until about 1914/15, had begun to abstract away recognisable features of the world from their paintings. But this process of visual analysis only went so far, resulting in an art 'abstracted' from reality, but still rooted in genres such as landscape, portraiture and still life. What it does seem to have done, however, was to establish the *possibility* of a fully abstract art, shorn of reference to an observable outside world. What followed, for both artists, can only be described as an imaginative leap to the possibility, not of breaking down a picture from an image of the world, but of building up a

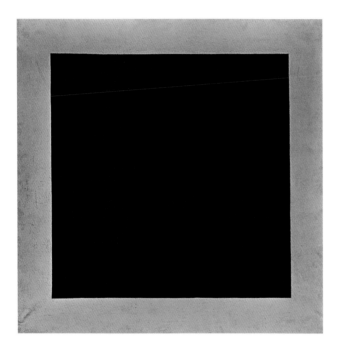

painting from an entirely abstract set of components. Regarded in this way, the *Black Square* stands as something like the first word in a new language, which can then be developed, elaborated and explored. Abstraction spoke of a search for pictorial essence, and a concomitant freedom from traditional constraints on art.

This freedom, however, carried with it certain dangers, dangers that have haunted abstract art throughout its existence. Who has the authority to say whether a particular configuration of shapes and colours constitutes a 'formal harmony', an 'aesthetic totality' – or whether it fails to do so? In practice this came down to the word of the artist, or more pointedly, the art critic. A system dependent on critical authority is also clearly a system ripe for lampoon. Hence the early avant-gardist joke of tricking a critic into waxing lyrical over an abstract 'painting' actually made by a brush tied to a donkey's tail. It is this kind of problem that Marcel Duchamp acutely highlighted, simultaneously with the emergence of abstraction itself. The works in question have since been widely canvassed as *the* predecessors of Conceptual art: the 'readymades'.

CONTEXT

As early as 1913, Duchamp began to take objects that had not originally been made as art objects, but as ordinary, utilitarian things, and to transplant them from their normal context of use into an alien context: an art context. The problem was that, once Pablo Picasso, Vladimir Tatlin or whoever had made an object of metal, cardboard, or wire and wood, potentially difficult problems

arose about its identity. There was no precedent for such a thing being regarded as a work of art. With benefit of hindsight, it is easy to see here how a crucial slippage can occur between establishing the identity of something as a work of art according to its possession of an essential formal quality, and the very opposite of that: treating it as art not because of its ineluctably right formal 'essence' to which we all assent, but because of contingent contextual factors, such as being displayed in an art exhibition or produced by someone upon whom the identity 'artist' has already been conferred. Duchamp's first 'Unassisted Readymade' was a metal bottlerack (fig.3). Despite his claim that the selection was arbitrary, one cannot but assume he chose something just close enough to the kinds of things that were beginning to emerge as sculptural constructions, to really force the issue of what was and wasn't art, of where the realm of the aesthetic ended and where utility began.

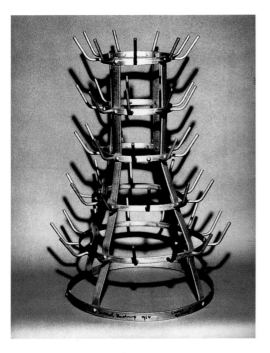

The real *cause célèbre* came a few years later with Duchamp's *Fountain* (fig.4). The story is well known. Duchamp, with his identity as a vanguard artist well established, was on the selection committee for an open sculpture exhibition in New York. He bought a urinal from a plumber's shop and submitted it as a sculpture, crudely signed with the pseudonym 'R. Mutt'. The work was rejected by the jury – despite the supposed openness of the exhibition to anyone who had paid their fee – and was not exhibited. Duchamp proceeded to run rings round the judges' published reasons for

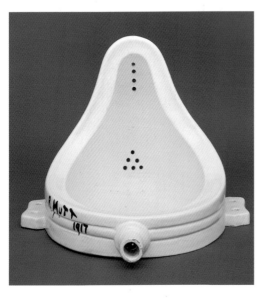

excluding the urinal: that it was somehow 'immoral', that it was 'merely' plumbing, and so on. The point was made even more seriously funny by the actually very close formal resemblance between the urinal and Constantin Brancusi's organically shaped abstract sculptures, some of which had already been exhibited in the United States.

3
Marcel Duchamp
Bottlerack 1914,
replica 1964
Metal
Edition of eight replicas
each 64.2 (25¼) high
Marcel Duchamp
Archives/Arturo
Schwarz Editions, Milan

4
Marcel Duchamp
Fountain 1917,
replica 1964
Porcelain
38 x 48 x 61
(15 x 19 x 24)
Tate

5
Jean-Léon Gérôme
O Pti Cien 1902
Oil on canvas
87 x 66 (34¼ x 26)
Private collection

LANGUAGE

Duchamp made his points with a bottlerack, a snow shovel and a urinal, but he also used language as a critique of art. The relation of language to modern art is curious. At one level, modernism had purged art of language. Academic art had been highly theorised, and was centred on the proximity of art and literature, on the recounting in visual terms of predominantly classical and biblical narratives. Modernism severs this connection. Notions of the 'innocent eye' or, as later modernist critics wrote, of an art that appeals 'to eyesight alone' add up to a domain from which language, with its connotations of the rational and the conventional, is expunged. In its stead, feeling and emotion are prioritised. But in another sense, modernism is haunted by language. Kasimir Malevich, Piet Mondrian and Wassily Kandinsky all wrote copiously on the theory of abstraction. In Cubism, words frequently appear in the paintings and collages themselves. In general, it is as if the relationship of language to modern art is that of a kind of frame, setting the terms of the emotional encounter of spectator and work of art. The spectator is, so to speak, positioned by theory before being freed to feel. Part of modernism's revolution had been to turn art away from a public realm of shared language and narrative, towards a private sphere of feeling and emotion, wherein these latter are conceived as somehow more fundamental than words, more natural, more 'universal'. One of Duchamp's strategies was to infect the world of ineffable feeling with a series of more or less clever (or dreadful) puns. Thus the 'LHOOQ' (which if read out loud sounds like *elle a chaud au cul*: 'she's got a hot ass') captioning the once-chaste and now mustachio'd *Mona Lisa*; and the name he coined for his own female alter ego, Rrose Selavy (*eros, c'est la vie*: 'eros, that's life'). These all disturb the sonorities of the canon and of the artistic author with the barbs of sex and slang. One of the pomposities of early modernism was the assumption by artists of the Romantically inspired role of visionary seer or holy fool. With his sexual innuendo as well as his contamination of what Kandinsky called 'the spiritual in art' through a range of ordinary commodities, Duchamp forces together what the high priests would separate. The punning shop-sign constructed in his old age by the arch-Academic painter Jean-Léon Gérôme was doubtless not conceived by him as 'art' at all (fig.5). In Duchamp's work, puns and jokes raised

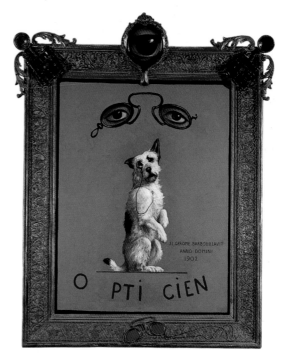

serious questions about where the boundaries of art lay.

Other avant-gardists continued to play the critical game, as modern art became sufficiently established and sufficiently (self-) important to warrant its own running commentary from within the ranks. Thus the Dadaist Francis Picabia played with the notion of language and visual art as distinct but related representational systems when he produced a painting made up almost entirely of signatures (fig.6). Later, the Surrealist René Magritte made a far-reaching point about visual and verbal representation, about representation and reality, with his painting of a pipe captioned *Ceci n'est pas un pipe* ('This is not a pipe'). Similarly, in his painting of a hand-mirror there appears, instead of the reflection of a human body, the equivalent linguistic phrase *corps humain* (fig.7). Along with the Dadaists and Surrealists, albeit in a different vein, the Soviet Constructivists drove through a critique of the aesthetically autonomous work of art and the form of life that underwrote it. With their notion of Art-into-Production, they abjured art as a symptom of bourgeois society that had to be replaced by practical contributions to the construction of socialism. This critique of bourgeois individualism animated the avant-garde in East and West alike, despite the different circumstances in which Dadaists, Surrealists and Constructivists found themselves.

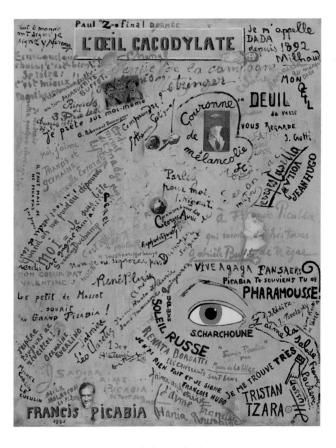

HISTORY

In the early decades of the twentieth century then, modernism had become established with the achievement of an autonomous, fully abstract art, but behind the apparent authority and self-sufficiency lurked a conceptual instability, which the critical avant-gardes immediately highlighted. Many of the recurrent themes of the early avant-garde, such as the identity of the work of art, the relationship of art and language, the relationship of art to a world of commodity production set against an ideology of independence and spiritual value, and what it was that the artist *did*, can all be seen to prefigure later Conceptual art. What is perhaps most surprising is the rapidity with which the options were followed through. By the First World War, with abstract art on the one hand and the readymade on the other, the conceptual limits of both essentialism and contextualism had already been sketched. A few years later, after the Bolshevik Revolution, the Constructivists were rejecting art as such.

Modernism was, so to speak, both established and tested to destruction at the same historical moment.

A double question prompts itself, then. At one level it is a silly question, impossible to answer. But also, given what we have just seen, it is an intriguing one. First, how did modernism survive? Second, why did Conceptual art take so long? If the poles of modernism and avant-gardism were established so early, why doesn't a fully fledged Conceptual art arise around 1918, or in the 1920s, instead of around 1968 and in the 1970s? The answer involves a recognition that art is not merely an independent system of signification. It is in fact a social practice, and the range of possible meanings available to art at any one time are circumscribed by its historical situation. As it turned out, the political crisis of the early twentieth century did not issue in a new world order. International socialism did not happen. The capitalist system inherited from the nineteenth century that fell apart in 1914 was restabilised in the 1920s, only to go into prolonged crisis again in 1929: a crisis that was not resolved until 1945. But after the rupture of *c.*1914–21, the status quo did succeed in getting the lid back on. Throughout this period, the practice of modern art seems to have been triangulated by the options of modernism, avant-gardism and Social Realism, sometimes in their pure forms, occasionally somewhat hybridised. The debate, moreover, was being conducted in a shrinking space as the 1930s advanced – unoccupied Europe (principally Paris, to a lesser extent London) and the United States (principally New York) – as Berlin and Moscow became very hostile places indeed for the practice of modern art. We may answer our question like this: at that juncture, modernism retained an emancipatory potential. Against a backdrop of Fascism and dictatorship, an independent art has a critical edge in and of itself. Autonomous modernism had its 'others', virtually from its inception, in the shape of the critical avant-gardes of Dada, Surrealism and Constructivism. But on the whole, modernism remained hegemonic, while the avant-gardes were either subordinated or extinguished. It is as if in order to be logically superseded, to have what Michael Fried called its 'primordial condition' (namely, that art is made to be *looked at*) challenged, modernism had first to have used up all its potential. Despite the readymade and productivism, it had not yet done so.

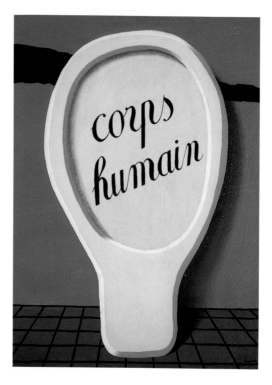

6
Francis Picabia
L'oeil cacodylate 1921
Oil on canvas and collage
148.6 x 117.4 (58½ x 46¼)
Musée National d'art Moderne – Centre Georges Pompidou, Paris

7
René Magritte
The Magic Mirror 1929
Oil on canvas
73 x 55 (28 x 21⅝)
The Scottish National Gallery of Modern Art, Edinburgh

3

AVANT-GARDISM RESUMED

The epochal political crisis of the 1930s loomed over the modern movement in art and the possibilities available remained circumscribed by it. Not until the reconfiguring of the world after the late 1940s, with the defeat of Fascism, the inception of the nuclear age, and the beginning of the Cold War, did the ground rules alter. After the initial period of post-war reconstruction, by the mid-1950s pictorial realism had become identified with artistic conservatism and repressive politics, while modernism spectacularly drew breath and issued in the New York school. Jackson Pollock, Clyfford Still, Barnett Newman, Mark Rothko and others produced abstract art on a scale and with a confidence that seemed to permit something new, something unavailable to Piet Mondrian, Joan Miró and other European abstract artists. Modernist theory moreover became highly developed, most notably in the writings of Clement Greenberg and, later, Michael Fried. Another factor to take into account is that, behind this intensified achievement at the levels of both practice and theory, the institutional ground of modernism was buttressed in an expanding range of galleries, museums and publications. The relationship between modernist art and its institutional support is not straightforward, however. In the 1940s and early 1950s, the stance of Pollock, Rothko and others was determinedly oppositional. Their art can hardly be said to have been made *for* the world that consumed it; if anything it was made despite it, or as part of an attempt to survive it. Yet later historians have often blurred the distinction, reacting against the claims for art's independence by associating modernist art with American power. By the 1960s, in the changed circumstances of opposition

to the Vietnam war, that *is* how things came to be seen, but in the immediate post-war period, modernist art had not been drained of its critical power.

Concurrently with the efflorescence of modernism in the 1950s, there also came a regeneration of the avant-garde in an array of non-medium-specific art activities. The seeds of a fully fledged Conceptual art are here. The rubble of wars, both hot and cold, had buried the avant-garde. The Soviet vanguard was quite simply obliterated. Not until the publication in 1962 of Camilla Gray's *The Great Experiment*, did some sense of the scope of Constructivism become apparent. Surrealism had dwindled in modernist eyes to the dream imagery of Salvador Dalí and René Magritte. Miró was regarded as a modernist abstract artist, and Max Ernst's technical radicalism was ignored. Greenberg judged Surrealist artists to be 'revivers of the literal past' and 'advance agents of a new conformist and best-selling art'. Walter Benjamin, whose 'Work of Art in the Age of Mechanical Reproduction' has, since its translation in the late 1960s, been endlessly invoked by a generation of engaged conceptualists, and who had remarked that Surrealism and Bolshevism were the twin keys to his critical thought, remained at that time entirely unknown in the English-speaking world. Even Duchamp was effectively brought back into focus by the newly emergent avant-garde of the mid-1950s. Jasper Johns, Robert Rauschenberg and John Cage in America, and Richard Hamilton in England, put Duchamp back on the map. It was, overall, less a matter of the original avant-gardes inspiring a new generation, than that generation making its own critical moves in the face of a triumphant modernism (and a triumphant consumer capitalism), and in the process discovering its antecedents and bringing them into the light.

RAUSCHENBERG

With the notable exception of Barnett Newman, post-war American modernism was essentially a school of gestural abstraction. Jackson Pollock, Clyfford Still, Willem de Kooning, Arshile Gorky, Franz Kline, even Mark Rothko, all depend upon our conviction of the felt authenticity, the necessity, of the autographic mark: a conviction that the singularity of that particular trace of that particular individual in response to that particular circumstance, precisely by being so true and unique, escapes contingency and ascends to a universal plane of feeling. So what does Robert Rauschenberg do? He consciously and deliberately paints the same thing twice. *Factum I* and *Factum II* (figs.8–9) are complex works. Rauschenberg had begun making 'combine paintings' in the mid-1950s, riding roughshod over the medium-specificity of modernist painting: photographs, newspapers, discarded objects including a variety of stuffed animals and automotive detritus. In Rauschenberg's own words, he sought to operate in the gap between art and life, which seems to have meant the gap between an urban, consumerist, media-led American modernity and what Greenberg called 'American-type painting'. By the standards of some of his later productions, *Factum I* and *Factum II* are relatively modest. The pictures clearly address the question of the uniqueness of the work of art, partly through the incorporation of photographs, partly through the act of doubling, itself repeated over and over again (two burning buildings, twice; two President Eisenhowers, twice; one photograph of two trees, twice).

But more particularly, the marks of art itself are doubled in the repeated daubs of Abstract Expressionist painting. These are *tokens* of spontaneity; authenticity is placed in quotation marks. The works' subject matter is the institutionalisation of spontaneity.

Factum I and *Factum II* need each other. The meaning of the work emerges in the space between the two pictures, or between that space and a third element: the description, or type, 'gestural abstract painting'. By the later 1950s, with so-called 'second generation' Abstract Expressionism, the struggle for authenticity had become a style. Four years earlier, Rauschenberg had taken a different kind

of distance from gestural abstraction in the iconoclastic *Erased de Kooning Drawing* (fig.10). Rauschenberg obtained a drawing from de Kooning (with the latter's support – he later said he chose a good one to make its erasure difficult) and then set to work laboriously rubbing it out. As a kind of critical symbol, the erased de Kooning could hardly be more economical: using gesture to efface gesture, using the same device of meaning-making to un-make one set of meanings and institute another, returning the achieved aesthetic unity of the finished work of art to the primordial unity whence it came – the blank canvas or sheet of paper (albeit visibly *worked*). In their different ways, both these

works by Rauschenberg represent answers to the question 'How to go on?' once the limit of individual expression has been reached, and moreover, become codified into system.

Duchamp had remarked in the 1940s that what he had intended with the readymades a quarter-century earlier was to return art to the service of the mind, having become bored by the limitations of an art in thrall to the senses. Through his friendship with the composer John Cage, Duchamp's legacy became associated in turn with a younger generation of artists, themselves seeking a way beyond modernism, albeit in very different circumstances from those facing Duchamp on the eve of the First World War. The central perception informing both generations' critical distance from their respective modernisms was an understanding of art as a system. Despite the well-rehearsed ideology of purification and distillation, of jettisoning the cultural baggage and getting down to the basics of signification, abstract art in its various forms operated as an institutionalised system of meaning production, with producers, distributors and consumers interdependently circling around each other. Modernist theory saw 'expression' as undercutting 'communication', as bursting through convention into human nature, a sphere as it were beneath language and convention. Rauschenberg's friend and fellow-artist Jasper Johns summed up the distance they had travelled away from this in his dictum 'I'm believing painting to be a language'. Johns had begun to try and work in art in the light of a view of meaning derived from the later philosophy of Ludwig Wittgenstein: 'the meaning is the use'. That is to say, the meaning of words is bound up with the contexts in which they are uttered. Meaning is produced through the working of sets of conventions, through the games we play with language. What happens to modernism if that turns out also to be the case for art?

EUROPE AND JAPAN

Simultaneously with the practice of Johns and Rauschenberg in the US, artists working on the other side of the Atlantic were also beginning to pick up the threads of a critical attitude to the conventions of mainstream modern art. (Indeed, both Johns and Rauschenberg had been to Europe.) The legacy of Surrealism provided the starting point for several initiatives. The Cobra group was founded in 1948, and the Situationist International in 1957. Asger Jorn, active in both groups, later wrote that their artistic activities were premised on the belief that 'visual art was a useless medium for creativity and thinking' and that, instead, 'art' should merge directly with social life in the city, becoming inseparable from action and thought. In France, Yves Klein initiated a series of gestures critical of conventional artistic genres: a series of identical blue (the pigment patented as International Klein Blue) monochrome paintings, which sold for different amounts; paintings made by traces of blue-paint-smeared bodies; paintings made by fire. One of the most clearly proto-Conceptual of these efforts came with Klein's 1958 exhibition at the Iris Clert gallery in Paris, titled *Le Vide* (The Void). Visitors to the opening, greeted by a military band hired for the occasion, passed through an International Klein Blue curtain over the gallery entrance into the 'exhibition': a completely empty gallery.

8
Robert Rauschenberg
Factum I 1957
Combine painting: oil, ink, crayon, paper, fabric, newspaper reproductions, and painted paper on canvas
155.9 x 90.2
(61⅜ x 35½)
The Museum of Contemporary Art, Los Angeles.The Panza Collection

9
Robert Rauschenberg
Factum II 1957
Combine painting: oil, ink, crayon, paper, fabric, newspaper reproductions, and painted paper on canvas
155.9 x 90.2
(61⅜ x 35½)
The Museum of Modern Art New York. Purchase and an anonymous gift and Louise Reinhardt Smith Bequest

Elsewhere, the Gutai group in Japan embarked on a series of performance-type activities in 1955/56, including a walk along a white line and the collection of water in the depressions of plastic strips loosely slung between trees (fig.11). The journal that had printed the Gutai manifesto in 1956, *Geijutsu-Shincho*, also developed links with the Italian avant-garde, publishing Piero Manzoni's essay 'Free Dimension', in which he commented: 'Expression, imagination, abstraction, are they not in themselves empty inventions?'. In Italy, Manzoni essayed the transformation of living people into 'works of art' by signing them

10
Robert Rauschenberg

Erased de Kooning Drawing 1953

Traces of ink and crayon on paper with hand-lettered ink label, in gold-leaf frame
64.1 x 55.3
(25¼ x 21¾)
San Francisco Museum of Modern Art. Purchased through a gift of Phyllis Wattis

11
Sadamasa Motonoga

Water 1956

As reconstructed for the 1987 Venice Biennale (Akira Kamayama's *Footprints* is visible in the foreground beneath *Water*)

12
Piero Manzoni

Merda d'artista no.20 1961

Metal and paper
4.8 x 6.5 (1⅞ x 2½)
Private collection, Milan

(painting) and standing them on portable plinths (sculpture). In 1959, he produced a series of works further challenging the 'visuality' of visual art. The 'Lines' were produced on rolls of paper turning on a machine, each action having a particular duration, and the completed drawing consisting of the length of paper covered by the line in that time. The twist is that the lined scroll is then encased in a cardboard cylinder, with a small section stuck to the outside and hence acting as a label, amplified by a written description including the length of the line, the date, etc. The drawing itself remains invisible. The

'work of art' thus included the idea of this invisibility as part of its subject matter. Manzoni's most extreme revelation of the increasingly commodified status of art came in 1961 with his *Merda d'artista*: ninety cans containing the artist's shit, the market price of which was the money equivalent of its weight in gold (fig.12).

The turn into the 1960s then, testifies to a deep division in art. On the one hand there was modernism, then at the height of its influence. Modernist art was premised on medium-specificity; that is, on the exploration of the expressive properties of the medium (paint, stone, wood, metal, etc.), aimed at the production of a concentrated aesthetic experience in the spectator. The mature work of Mark Rothko arguably represents the most intense achievement of this tradition, though by the early 1960s the weight of the claim that modernism was still moving was being borne by the then newly emerging work of the generation of so-called 'post-painterly' abstractionists, including Morris Louis, Kenneth Noland and Jules Olitski. The *locus classicus* for the theory underpinning this painting was Greenberg's essay collection *Art and Culture*, which appeared in 1961, amplified by later texts such as 'After Abstract Expressionism', 'Post Painterly Abstraction' and, above all, 'Modernist Painting' (originally composed in 1960, though omitted from *Art and Culture*, and appearing in definitive form in 1965). In the mid-1960s, Greenberg's writing was complemented and extended, most notably by the work of Michael Fried. This apparently integrated cluster of theory and practice

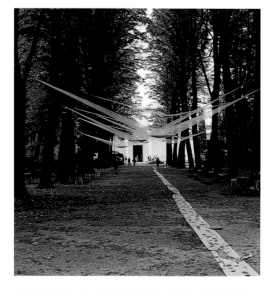

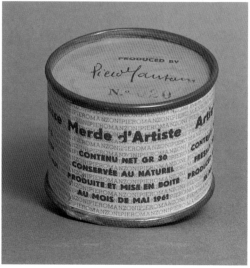

provided the point of negative reference for a much more heterogeneous range of 'neo-avant-garde' activities, whose protagonists tended to consider themselves critical of a status quo, both social and artistic, of which they believed modernism to be a part.

FLUXUS

One of the most immediately obvious features of the range of avant-garde practices broadly opposed to modernism was their abrogation of medium-specificity. Allan Kaprow wrote: 'The young artist of today need no longer say "I am a painter" or "a poet" or "a dancer". He is simply an "artist". All of life will be open to him.' This kind of attitude tended to create a very open situation, quite distinct from the exclusivity of modernist art. That openness was exemplified by Fluxus. As we have already noted, the first use of the term 'Concept Art' occurs in the writings of Henry Flynt in 1961. Flynt's article arose out of Fluxus activity in New York, but the group had a wider catchment, embracing artists from Asia and Europe, as well as the United States. Yoko Ono had taken up residence in New York and was involved in many Fluxus activities both there and in her native Japan. These ranged from 'instruction

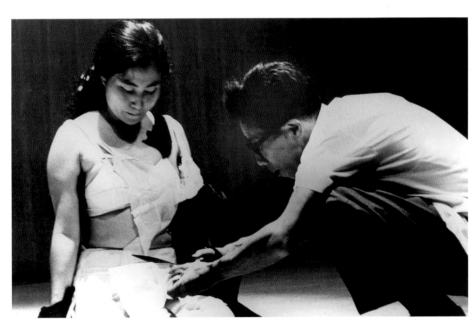

13
Yoko Ono

Cut Piece 1964

Photograph of
performance in Kyoto

14
George Maciunas

Fluxus Manifesto 1963

Offset on paper
20.3 x 15.2 (8 x 6)
Gilbert Leila Silverman
Fluxus Collection

paintings', to vocalisations at 'concrete music' events, to performances. Some of these, in her use of her own body, and the evocation of extremely edgy male/female power relations, prefigure later more overtly feminist work. One resonant example was the *Cut Piece* in which Ono knelt on stage while male members of the audience one by one cut away pieces of her clothing with a large pair of scissors (fig.13).

The prevailing ethos of Fluxus was a mixture of sharp criticism and whimsy, captured by Dick Higgins' remark that many artists in the late 1950s and early 1960s began to believe that: 'coffee cups can be more beautiful than fancy sculptures'. This sense of the potential beauty of the overlooked and the ordinary chimes with a long tradition of avant-gardist activity, keeping its distance from the pomp and protocols of 'high culture', which it roundly identified with the bourgeoisie. A photograph of 1963 shows Henry Flynt and a

colleague Jack Smith protesting in true avant-garde style outside the entrance to the Museum of Modern Art in New York, with flimsy placards hanging round their necks reading 'Demolish Art Museums!' and 'Demolish Serious Culture!'. George Maciunas, who coined the name Fluxus, underlined the socio-political implications of the attitude in a text published as the group's *Manifesto* in 1963. Collaged together with dictionary definitions of the word 'flux', were Maciunas' words (fig.14):

Manifesto:

2. To affect, or bring to a certain state, by subjecting to, or treating with, a flux. "*Fluxed* into another world." *South.*
3. *Med.* To cause a discharge from, as in purging.

flux (flŭks), *n.* [OF., fr. L. *fluxus*, fr. *fluere*, *fluxum*, to flow. See FLUENT; cf. FLUSH, *n.* (of cards).] 1. *Med.* a A flowing or fluid discharge from the bowels or other part; esp., an excessive and morbid discharge; as, the bloody *flux*, or dysentery. b The matter thus discharged.

Purge the world of bourgeois sickness, "intellectual", professional & commercialized culture, PURGE the world of dead art, imitation, artificial art, abstract art, illusionistic art, mathematical art, — PURGE THE WORLD OF "EUROPANISM"!

2. Act of flowing: a continuous moving on or passing by, as of a flowing stream; a continuing succession of changes.
3. A stream; copious flow; flood; outflow.
4. The setting in of the tide toward the shore. Cf. REFLUX.
5. State of being liquid through heat; fusion. *Rare.*

PROMOTE A REVOLUTIONARY FLOOD AND TIDE IN ART,
Promote living art, anti-art, promote NON ART REALITY to be fully grasped by all peoples, not only critics, dilettantes and professionals.

7. *Chem. & Metal.* a Any substance or mixture used to promote fusion, esp. the fusion of metals or minerals. Common metallurgical fluxes are silica and silicates (acidic), lime and limestone (basic), and fluorite (neutral). b Any substance applied to surfaces to be joined by soldering or welding, just prior to or during the operation, to clean and free them from oxide, thus promoting their union, as rosin.

FUSE the cadres of cultural, social & political revolutionaries into united front & action.

Purge the world of bourgeois sickness, 'intellectual', professional & commercialized culture; purge the world of dead art, imitation, artificial art, abstract art ... Promote living art, anti-art, promote non-art reality to be grasped by all peoples, not only critics, dilettantes and professionals. Fuse the cadres of cultural, social & political revolutionaries into united front & action.

Now that Fluxus paraphernalia is itself being mummified in the institutions of high culture, many of their activities seem in retrospect to have had more in common with Monty Python than with a united front of revolutionary action. But even this should not be underestimated. Acting out *homo ludens* was a fair riposte to the regimentation and stuffed-shirt proprieties of mainstream post-war culture. Faced now by our own brands of cultural correctness, and the ever-expanding girth of 'Art', it may well be that the best way to take Fluxus seriously is not to.

In late 1961, working as a designer with the American Air Force, Maciunas went to Germany where he staged a number of music and performance-based events. Among those he met and worked with was the Korean artist Nam June Paik. At the Fluxus festival in Wiesbaden in 1962, Paik performed *Zen For Head*, in which he dragged his head, dipped in paint, along a roll of Olivetti typewriter paper, to a musical score by La Monte Young. This was titled *Composition #10, 1960*, and was subtitled *To Bob Morris*. Young was also editor of the Fluxus *Anthology*, which contained Flynt's 'Concept Art' piece, as well as a text by Morris. Among those who also became involved in Fluxus in Germany was Joseph Beuys (fig.15). Troels Andersen's

description of Beuys' *Eurasia* performance from 1966, reprinted in Lippard's *Six Years* anthology, is worth quoting at length:

> Kneeling, Beuys slowly pushed two small crosses which were lying on the floor towards a blackboard; on each cross was a watch with an adjusted alarm. On the board he drew a cross which he then half erased; underneath he wrote 'Eurasia'. The remainder of the piece consisted of Beuys manoeuvring along a marked line, a dead rabbit whose legs and ears were extended by long thin black wooden poles. When the rabbit was on his shoulders, the poles touched the floor. Beuys moved from the wall to the board where he deposited the rabbit. On the way back, three things happened: he sprinkled white powder between the rabbit's legs, put a thermometer in its mouth, and blew into a tube. Afterwards he turned to the board with the erased cross and allowed the rabbit to twitch his ears while he himself allowed one foot, which was tied to an iron plate, to float over a similar plate, on the floor. This was the main content of the action. The symbols are completely clear and they are all translatable. The division of the cross is the split between East and West, Rome and Byzantium. The half cross is the United Europe and Asia, to which the rabbit is on its way. The iron plate on the floor is a metaphor — it is hard to walk and the ground is frozen.

Through activities like this, Beuys rapidly became one of the most prominent artists in the international avant-garde. His incorporation of animals into his performances, and activities such as the planting of trees, combined with extensive free-form 'teaching' sessions, also led to his being seen as a significant figure in the politics of culture, particularly in respect of the emergence of the 'Green' movement in Germany. But it is worth recognising that however suggestive and uncanny they may have been, Beuys' activities remain somewhat ambivalent. Thus, while the *Eurasia* performance may well function allegorically, it is quite wrong to say that its symbols are 'completely clear'. They are not. Part of what has happened in modernity has been the fracturing of public symbolism, or its etiolation into the terms and themes of the mass media. Allegories such as the one performed here require assent to stipulative definition if they are to work ('The erased cross means ...'; 'The dead rabbit means ...'; 'Fat signifies X'; 'Felt signifies Y'; and so on). And that requires assent to authority, namely the authority of the artist conceived as shaman. Beuys may offer a critique of the materialism of the consumer society, and of power relations in the world. Yet while speaking a language of enabling and opportunity on the one hand (as in his argument that 'Not just a few are called, but everyone'), he relied on the exercise of charismatic authority to establish his platform. One thing we can perhaps say with 'complete clarity' is that Beuys can be positioned within an irrationalist tendency in German thought and art with its roots in the late eighteenth century, in the Romantic critique of Enlightenment rationalism.

As with many other kinds of performance-based art, this raises questions of the kind we posed at the start: about the nature of Conceptual art, and its relationship to criticism, analysis and the demystification of art's sustaining ideologies. How one conceives Fluxus activities in general, or Beuys in particular, in relation to Conceptual art is largely a matter of definition. If we restrict our sense of Conceptual art to a language-based investigation of the

15
Joseph Beuys
Eurasia 1966
Photograph of performance at the Tate Gallery

assumptions of modernism, Fluxus appears as a kind of noise on the channel, a playground of international bohemia. If we extend our sense of conceptualism to include a broad band of activities unified if at all only by their abrogation of medium-specificity, then Fluxus is fundamental.

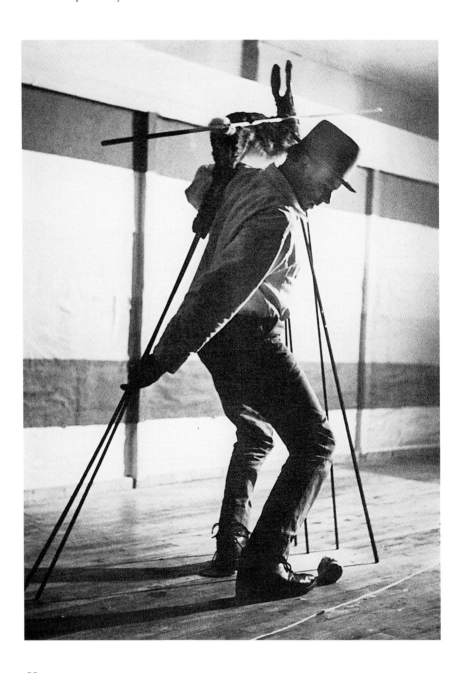

MORRIS

One crucial link between the Duchampian tradition, Fluxus, and Conceptual art proper is provided by the work of Robert Morris from the early 1960s. In addition to performance-based work with Yvonne Rainer, some of which

included the modular elements he later developed into his Minimalist sculpture, during the early 1960s Morris was also making a range of enigmatic 'Duchampian' objects. Some of these involved quotidian items (such as a bunch of keys or a ruler) cast in lead; one employed a photograph of the artist's body; there were casts of body parts and traces (a fist, footprints); and many involved words. Some were highly self-referential, seeming to parody the modernist obsession with the autonomy of the art object. With one foot in the camp of the readymade, *Card File* recorded the process of its own production through the written entries in an alphabetically listed series of forty-four file cards: from Accidents to Working, from the moment of conception ('whilst drinking

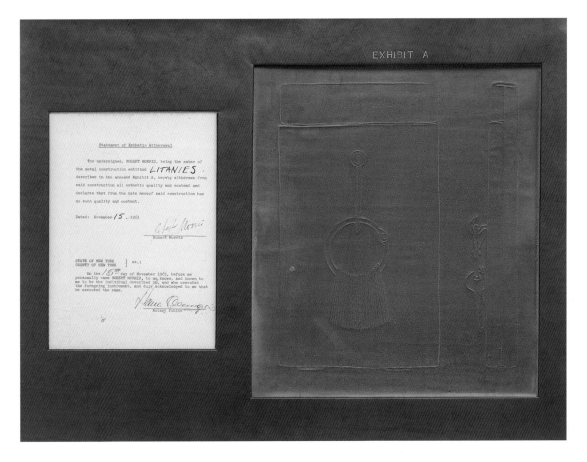

coffee in the New York Public Library') to going out to buy the file itself.

A key area of contention between modernism and the more diversified avant-garde concerned the status of the aesthetic. For modernists, it is not too much to say that the aesthetic was the be-all and end-all of art, its unique and proper area of competence. In the case of Fluxus, it was less a question of rejecting the notion of the aesthetic as of broadening its range of reference, outwards from the medium-specific, formally achieved harmony of a modernist painting to, potentially, anything, an object, a sound or an action. In later Conceptual art, the question of the aesthetic was strategically put in

brackets: not so much a goal for critical art as an issue for it to address. A key point at issue concerned the matter of whose business it was to say whether something was a work of art or not, and whether it had aesthetic merit or not. This had been an issue shadowing art since the second decade of the twentieth century. In 1963, Morris took the opportunity to address it directly. His work *Litanies*, exhibited at his first one-man show in New York, was one of the types of object we have already mentioned: a lead-covered box containing a keyhole and a bunch of keys, the one forever out of reach of the other (and hence capturing some of the poetry associated with earlier enigmatic objects produced by artists such as Duchamp, the Surrealists and, later, Jasper Johns). The work was bought by Philip Johnson (and subsequently entered the collection of the Museum of Modern Art). However, Johnson was late in paying for the work, thereby giving Morris the opportunity to invert the Duchampian strategy of conferring art status on objects originally produced for other purposes. Morris now produced a two-part piece: on the right-hand side a flat lead imprint of *Litanies*, taken from two aspects, front-on and side-on, like a police mug-shot. This was captioned 'Exhibit A'. To the left of this, but enclosed in the same overall frame, was a typewritten sheet of paper, signed by Morris and legally witnessed by a Public Notary. It read: 'The undersigned, ROBERT MORRIS, being the maker of the metal construction entitled *Litanies* described in the annexed Exhibit A, hereby withdraws from said construction all aesthetic quality and content and declares that from the date hereof said construction has no such quality and content. Dated, November 15, 1963' (fig.16). If the authority of the artist was all-powerful, if it really was the case, as Donald Judd put it, that 'If the artist says it's art, then it's art', then the claim cut both ways. Morris is in effect saying that, by the same token, if the artist said it *wasn't* art, then it wasn't.

Except of course, that it still was. No less so than in the case of Duchamp's household goods or even Manzoni's shit, Morris's assertion merely added up to one more knight's move on art's infinitely extendable checkerboard. By the mid-1960s, then, things had reached a critical position. Modernist art was, at least according to the rhetorical noise surrounding it, the acme of purified self-reference. All-over colour-field paintings had pushed the aesthetic onto such a high plateau of sensibility that for anyone not fully committed to the argument, it had effectively disappeared out of sight. For its part, the avant-garde had demonstrated over a history as long as modernism's own that the potential boundaries of art were wide indeed. The point where art curved around its own identity and became coterminous with everything else was as dangerous as it was liberating.

16
Robert Morris

Document 1963

Typed and notarised statement on paper and sheet of lead over wood mounted on imitation leather mat 44.8 x 60.4 (17⅝ x 23¾) Museum of Modern Art New York. Gift of Philip Johnson

4

17
Frank Stella
Six Mile Bottom 1960
Metallic paint on
canvas
300 x 182.2
(118 x 71 ¾)
Tate

ART AS IDEA

Conceptual art grew in a space created by the avant-garde, and used it to mount
a far-reaching critique of the assumptions of artistic modernism, in particular
its exclusive focus on the aesthetic and claims for the autonomy of art. The
modernist critic Clement Greenberg, discussing the origins of modernism in
the late nineteenth century, had spoken of a process of 'dialectical inversion'.
He was referring to the paradoxical development wherein modern artists had
set out to try to find adequately new ways of representing their unprecedented
modern world of boulevards, café-concerts and railway stations, and had ended
by producing an art of autonomous visual effects. It can be argued that the
reverse happened with Conceptual art. Claims that painting 'appealed to
eyesight alone', that visual art's 'primordial condition' was that it is made to be
looked at, themselves became the subjects of a new kind of reflection. And the
paradox this time was that raising questions about autonomous art opened up a
register of far wider issues; the modern world began to return to the agenda of
a modern art. This is, of course, to overstate its absence. No less a figure than
Jackson Pollock had said of his abstract art that it was a response to the
demands of a new age. But *how* abstract art did that, and what the nature of its
response was, had become less and less clear as modernism had turned into
'post-painterly abstraction'. In the rapidly changing conditions of the 1960s,
many artists grew sceptical of what was beginning to look like a modern
incarnation of art for art's sake. As Claes Oldenburg put it: 'I am for an art that
does something other than sit on its ass in a museum'. The title of a later
retrospective exhibition of 1995 encapsulated the new agenda: Conceptual art

was about 'Reconsidering the Object of Art', and in both senses, moreover, of the word 'object'. It was about raising questions concerning the *products* of art activity, and about art's *purpose* in relation to a wider history of modernity.

STELLA AND MINIMALISM

The work of Frank Stella represents a crucial point of fracture in the confrontation between modernism and the variously counter-modernist practices of the avant-garde, which gave rise to Conceptual art. As early as 1959, Stella had exhibited canvases of an abstraction so thoroughgoing that, while they asserted the modernist logic of reduction, they did it so emphatically that they almost annulled modernism's other component, the achievement of expressive effect. Stella's 'Black Paintings', composed of regular black stripes echoing the canvas shape, the paint applied flat with a decorator's brush, embodied a literalism that threatened the evocative aspect of modernist painting even as it took its materialism to a new level. This move was confirmed over the next few years as Stella used ever more artificial paints, such as aluminium and copper; deepened the stretcher bars until the painting became a slab mounted parallel to the wall; and above all, shaped the canvas, cutting out notches or angling the sides so that the overall shape echoed the internal form (fig.17). What makes these works so significant for the crisis of modernism and the emergence of Conceptual art is that they were championed *both* by the Minimalist sculptor Donald Judd *and* by the modernist critic Michael Fried.

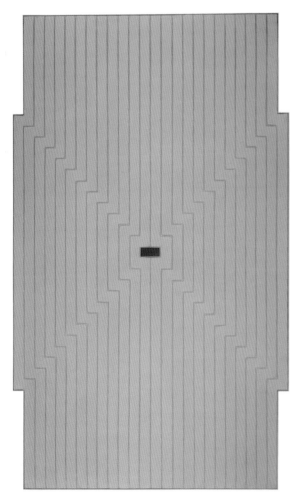

In one of his most elusively complex attempts to forge a language for modernist painting, the essay 'Shape as Form', Fried argued that by closing the gap between the 'literal shape' of the painting and its 'depicted shape', Stella achieved a new and more forceful unity of form that was capable of compelling a conviction of aesthetic value in the sympathetic spectator: as if Stella had achieved a virtualisation of the literal. For Judd, however, the lesson seems to have been the opposite. In his view, the painting of Barnett Newman and subsequently Kenneth Noland had taken abstraction to a new level of wholeness and unity, but in so doing they had spelt the end of painting. Only so much could be done with a uniform rectangular surface parallel to the wall.

Stella's emphasis on the literalness of the painting's support through his deep stretchers and shaped canvases pointed to something else: to getting the work off the wall and into three-dimensional space. The result was an art of what Judd called 'Specific Objects', and what the world has come to know as Minimalism.

For Fried, this was tantamount to a declaration of war on modernism – the invasion of art by what he called 'theatricality': a kind of staged performance encountered in literal space and in real time by an embodied spectator, *not* the elevation out of that condition into an instant of aesthetic 'presentness'. For Fried, modernist art defeated time, the realm of contingency, and to reduce art to the condition of everything else was something like treason. For many in the generation of the mid-1960s, however, it was not; it was a sudden and fundamental opening up of art. It was another of those charged moments of the kind we have already noted c.1910–15, when abstract art, all form and transhistorical essence, issued in the readymade, all contingency and context.

The Minimal object, literal thing in real space, shorn of composition and handicraft, the endgame for the modernist preoccupation with form, went through the looking glass and in no time at all gave rise to Antiform: the work of art as anything, bits of waste, felt, undifferentiated stuff, and even no 'things' at all but actions and 'ideas'. Once again, as at the beginning of abstraction, it is as if the parameters of the field were mapped in a moment. That extended 'moment', from the beginning of the decade to the mid-1960s, when modernism gave onto Minimalism, which in turn gave onto Antiform, may be regarded as the gestation period of a full-blown Conceptual art.

PAINTING

A kind of test case was provided by the painting of Kenneth Noland and Jules Olitski (fig.18). For Michael Fried, this work was exemplary of that to which modernist art could aspire. As with Stella, it 'compelled conviction'. What it

compelled conviction *of* was an intensely expressed and distilled feeling, equivalent to that provided by the canonical art of the past; that one could be carried by it into a state of 'grace', and by implication out of the world of time, decay and death. For Lucy Lippard, however, Olitski's paintings were 'visual muzak'. This amounts to rather more than saying that they were boring. Readers will recall that for early modernist critics and artists, the condition of music was something to be striven for, a liberation of art from the service of literary narrative. Abstraction offered the hope of a visual equivalent to music, a free art. 'Muzak' is the name given to a kind of commercially produced ambient music, from which all the peaks and troughs have been erased, which is used to provide soothing background in places such as elevators, airports and supermarkets. This is music as a means to an end, an adjunct to consumption. To see modernist art as visual muzak was thus by implication a claim that modern art was client to a power structure that itself remained hidden. To many, it was as if modernism had become, not the representative of the aesthetic in a fallen world, but precisely an anaesthetic ideology.

18
Jules Olitski

Twice Disarmed 1968

Acrylic on canvas
233.3 x 666.8
(92 x 212½)
The Metropolitan
Museum of Art. Gift of
Mrs and Mrs Eugene M.
Schwartz 1986

19
Mel Ramsden

Secret Painting
1967–8

Liquitex on canvas
122 x 122 (48⅛ x 48⅛)
Photostat 91 x 122
(35⅞ x 48⅛)
Collection of Bruno
Bischofberger, Zürich

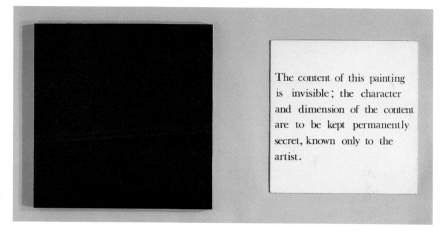

The content of this painting is invisible; the character and dimension of the content are to be kept permanently secret, known only to the artist.

Lippard's comment represented the judgement of a critic. But early Conceptual artists were already analysing, even parodying abstraction in practice. And once again, as with so many earlier avant-garde incursions, it was an international phenomenon. As early as 1965, in England, Michael Baldwin stretched a synthetic, reflective plastic sheet to produce 'mirror paintings', the sheerest possible monochrome, which, of course, captured the passing world in their pure surfaces. In New York in 1968, Mel Ramsden produced a canvas on whose grey ground was stencilled the figures '94%' and '6%'; it was then dubbed *100% Abstract*. Slightly earlier, he had also parodied the mystique that shadowed abstraction in *Secret Painting* (1967–8). In an acknowledgement of abstraction's originary moment, this was a two-part work consisting of a black square and an accompanying text that read: 'The content of this painting is invisible; the character and dimensions of the content are to be kept permanently secret, known only to the artist' (fig.19). Also during 1967–8, in California, John Baldessari produced a series of paintings consisting of quotations from art critics or from art-appreciation textbooks, reproduced on

the scale of modernist abstraction (fig.20). Not all German art was hostage to mysticism either: in 1969 Sigmar Polke parodied the genre with *The Higher Powers Command: Paint the Right Hand Corner Black* (fig.21).

IDEAS

One gesture sums up the changed climate. In August 1966, the English artist John Latham, employed as a part-time lecturer at St Martins School of Art in

COMPOSING ON A CANVAS.

STUDY THE COMPOSITION OF PAINTINGS. ASK YOURSELF QUESTIONS WHEN STANDING IN FRONT OF A WELL COMPOSED PICTURE. WHAT FORMAT IS USED ? WHAT IS THE PROPORTION OF HEIGHT TO WIDTH ? WHAT IS THE CENTRAL OBJECT ? WHERE IS IT SITUATED ? HOW IS IT RELATED TO THE FORMAT ? WHAT ARE THE MAIN DIRECTIONAL FORCES ? THE MINOR ONES ? HOW ARE THE SHADES OF DARK AND LIGHT DISTRIBUTED ? WHERE ARE THE DARK SPOTS CONCENTRATED ? THE LIGHT SPOTS ? HOW ARE THE EDGES OF THE PICTURE DRAWN INTO THE PICTURE ITSELF ? ANSWER THESE QUESTIONS FOR YOURSELF WHILE LOOKING AT A FAIRLY UNCOM - PLICATED PICTURE.

20
John Baldessari

Composing on Canvas
1966-8

Acrylic on canvas
289.6 x 243.8
(114 x 96)
Museum of
Contemporary Art, San
Diego. Gift of the artist

21
Sigmar Polke

*The Higher Powers
Command: Paint the
Right Hand Corner
Black!* 1969

Lacquer on canvas
150 x 125.5
(59 x 49¾)
Joseph Froehlich
Collection, Stuttgart

London, where modernism was a powerful influence on the teaching, withdrew a copy of Greenberg's *Art and Culture* from the college library. He then invited like-minded artists and students to a 'chew-in' (mimicking the 'teach-ins' and 'sit-ins' of the time), which involved selecting a page, tearing it out, masticating it, and spitting the results into a receptacle provided. Latham subsequently broke down the pulp into liquid with a concoction of chemicals into which yeast was introduced. When the library requested its book back, it received a

test-tube of alcohol: Latham had 'distilled' *Art and Culture*. Latham duly got the sack, and art inherited a Conceptual icon in the shape of a Duchampian-looking suitcase containing a copy of the book, the glass vials and chemicals, and Latham's letter of dismissal (fig.22). As a marker of the subsequent change wrought by Conceptual art, it is interesting to note that not only does Latham's suitcase now reside in the collection of the Museum of Modern Art in New York, but that in the year 2000 it was displayed at the entrance to that

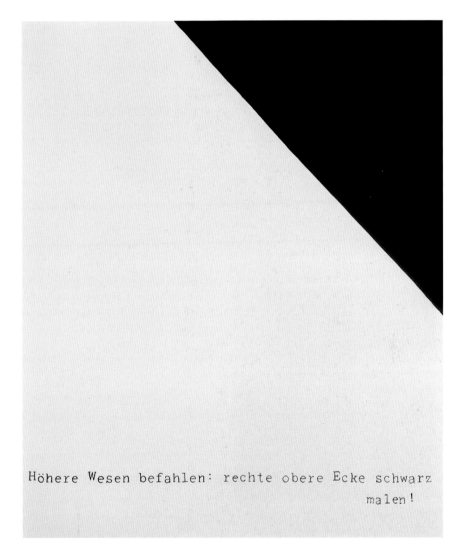

Höhere Wesen befahlen: rechte obere Ecke schwarz
malen!

museum's survey of the art of the late twentieth century.

A sea-change was taking place. If academic art had traded on its affinities with literature, and had been organised around narratives, modernism had been an art of sensation, something that aspired to undercut learning and literature at the level of the emotions. Now, the disarticulation of art from the intellect was beginning to appear increasingly suspect. Suddenly the Idea was king. The combination of the crisis of modernism and the proliferation of avant-garde

gambits meant questions had to be asked about 'the object' of art; and crucially, *not* by academics, critics, historians, philosophers and other interpreters, but by artists themselves. Theory, so to speak, became a practical matter.

Questions of representation and perception became key issues. The Dutch artist Jan Dibbets produced a series of 'perspective corrections' by plotting lines on a receding wall, or landscape plane, such that when photographed they appeared to be a square parallel to the picture plane (fig.23). In *Photopath*, Victor Burgin photographed a section of the floor of a room, blew the resulting monochrome pictures up to life size, and laid them down over the original floor (fig.34). Joseph Kosuth's 'Proto-

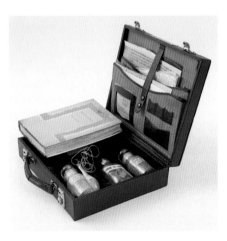

investigations', including sheets of glass, neon lights, and compound works involving objects, photographs and words, are said to have been realised conceptually – as 'ideas' – as early as 1965, though they were not exhibited until later. Be that as it may, the works are representative of early conceptual inquiry into the object of art. In *One and Five Clocks*, *One and Three Chairs* and kindred works, Kosuth drew attention to the relationship between a physical object and different kinds of representation of it: visual, in the case of the photographs, verbal in terms of the dictionary definitions (fig.24).

Kosuth's early work was part of a wider tendency that had emerged in New York. An exhibition organised by Mel Bochner in late 1966 staked out some of the ground. A hundred drawings of various kinds were collected for an end-of-year show at the School of Visual Arts. Bureaucratic obstruction meant that the drawings could not be conventionally framed for display. Bochner's solution was to use the then new Xerox technology to photocopy them, standard size and four times over, and 'display' them in four large, loose-leaf notebooks placed in the gallery on the kinds of plinth normally used for sculpture (fig.25). Out of a mixture of accident and design, Bochner had orchestrated an event that occupied the very territory towards which vanguard activity seemed to be heading, the hinterland where art met various forms of non-art, and it became hard to tell the difference. The problematic status of the installation was sustained by the interaction of its constituent elements: the variety of the 'drawings' themselves,

22
John Latham
Art and Culture 1966
Assemblage: leather case containing book, letters, photostats, etc., and labelled vials filled with powders and liquids.
7.9 x 28.2 x 25.3 (3⅛ x 11⅛ x 10)
The Museum of Modern Art, New York. Blanchette Rockefeller Fund

23
Jan Dibbets
Perspective Correction 1969
Photograph of installation

24
Joseph Kosuth
Clock (One and Five) English/Latin version 1965 (Exhibition version 1997)
Clock, photographs and printed texts on paper
Tate

which ranged from diagrams and working sketches by artists such as Sol LeWitt and Don Judd, to invoices, mathematical calculations, and a score by John Cage, as well as the inclusion of the gallery's floor plan and a diagram of the photocopier used to duplicate them; all of this combined with the 'art-like' mode of display and, not least, the title, *Working Drawings and Other Visible Things Not Necessarily Meant to be Viewed as Art*, to make manifest the indeterminate thing that the 'work of art' had become. In 1966 'Conceptual art' did not exist as a named 'movement', but Bochner's show indicates the direction in which things were headed.

In 1967, Kosuth organised the exhibitions *Nonanthropomorphic Art* and *Normal Art* in temporarily rented spaces in New York. Both shows included work by Kosuth himself and by Christine Kozlov, whose contributions are often taken to exemplify the early role of women artists in conceptualism. In the first she showed *Compositions for Audio Structures*, photocopied 'drawings' representing sounds; and in the second, two rolls of film, one completely black, one

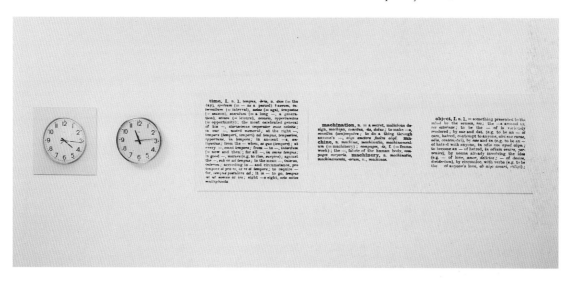

completely transparent. Later she exhibited a tape recorder with a continuous loop, recording, playing back and erasing the sounds in the exhibition space (fig.26). As early as 1966, Mel Ramsden and Ian Burn had produced *Soft Tape*, a work consisting of a tape recorder playing back sounds pitched just below the threshold of audibility, the aim being to inject 'tension and possibility' into the exchange of information (and by implication to disturb the convention of 'contemplation' in the face of the work of art). In all these pieces, the hardware was of relatively minor significance. The situation was arriving at the point where, as Kosuth wrote in his notes accompanying the *Nonanthropomorphic* exhibition, 'the actual works of art are the ideas'.

DEMATERIALISATION

In the late 1960s, Kosuth, along with Robert Barry, Douglas Huebler and Lawrence Weiner, became associated with the dealer Seth Siegelaub, producing work that questioned the limits of what could count as a work of art, what an

exhibition was, and what it was that an artist *did*. Siegelaub challenged conventional expectations by staging exhibitions that reversed the normal relationship between the work on display and the catalogue. In the *January* exhibition of 1969, while some physical examples of work were shown in temporarily rented premises, the real site of the exhibition was the catalogue, which in Siegelaub's terms now became 'primary' rather than 'secondary' information. In a notable shift, artwork was now being conceived as 'information', which could be circulated more efficiently through the medium of texts and photographs than through the transportation of physical objects.

It was the work of such artists that stimulated the claim that the tendency uniting the Conceptual avant-garde was the 'dematerialisation' of the object of art: a thesis advanced by Lucy Lippard and John Chandler in *Arts Magazine* in February 1968. The most literal example of this strategy of 'dematerialisation' is afforded by the work of Robert Barry. Barry began with small monochrome canvases hung at disparate points on the gallery wall, which in exhibition therefore appeared to bring into play the space between them. From here he moved to wires. *Untitled* of 1968 is a nylon thread weighted down with a steel disc, hanging vertically, and almost invisibly, from the ceiling. The wires were about as far as solid matter could be taken into the realm of transparency. The next step, logically enough, was gas. The *Inert Gas Series* of 1969 took in gases such as neon, xenon, and helium. The text for *Helium* reads: 'Sometime during the morning of March 4, 1969, 2 cubic feet of helium was returned to the atmosphere'. Tellingly, the event is recorded in a photograph (fig.27). Other, yet more 'dematerialised' works by Barry include *Telepathic Piece*, 'something close in space and time but not yet known to me', and the assertion that 'for the duration of the exhibition, the gallery will remain closed', a work that was simultaneously 'shown' at several different venues in the USA and Europe.

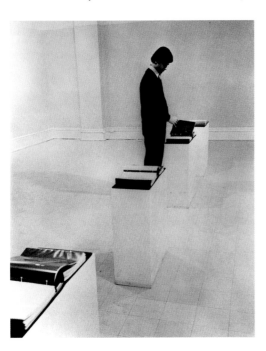

Lawrence Weiner made the point about the obsolescence of physical objects with rather more aplomb. He had originally been a painter, producing geometrically striped or monochrome, shaped canvases in the early to mid 1960s, but he had also performed some more 'exploratory' sculptural work involving the removal rather than the installation of material by blowing holes in the desert with dynamite. From 1968 Weiner began presenting a series of enigmatic propositions relating to similar kinds of actions. These included, 'One hole in the ground approximately 1′ × 1′ × 1′. One gallon water based paint

poured into this hole' (Statement 010, 1968); 'Two minutes of spray paint directly upon the floor from a standard aerosol spray can' (Statement 017, 1968). Picking up on his earlier work, Weiner also began removing material rather than installing it: 'A 36" × 36" removal to the lathing or support wall of plaster or wall board from a wall' (Statement 021, 1968: fig.28); 'A square removal from a rug in use' (Statement 054, 1969). The twist that Weiner applied to this from 1969 onwards, when it was first published in Siegelaub's *January* catalogue, was the accompaniment of each Statement with the tripartite rider: '1. The artist may construct the work. 2. The work may be fabricated. 3. The work need not be

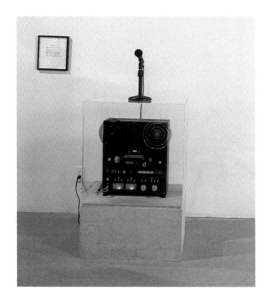

built.' That is to say, the 'work' lay in the idea. It did not have to be physically realised in order to enjoy the status of 'work of art'. And moreover, if it were physically realised, that realisation did not have to be at the hand of the artist. In these early works, Weiner probed the limits of some central assumptions about the nature of artists and artworks while seeming to do almost nothing. Therein lay, if not the 'art', then much of the attitude that made it compelling. In some of the most thought-provoking early Conceptual art, there can be felt a faint trace of that Zen cool allied to a quizzical humour that so absorbed those around Cage back in the 1950s and marked them out from the Dionysian exertions of Abstract Expressionism. The laid-back attitude of the wider counter-culture, its slightly nomadic quality, as well as its general air of resistance to gloss and consumption, hovered alongside many Conceptual manifestations. An English variant occurs in Keith Arnatt's take on dematerialisation, his *Self-Burial* of 1969 (fig.29). Arnatt wrote, 'the continual reference to the disappearance of the art object suggested to me the eventual disappearance of the artist himself. The photographic sequence may be seen as a metaphor for this imagined impending condition'. *Self-Burial* represents an ironic portrait of the fate of the modernist author at the hands of Conceptual art. It also happens to be funny.

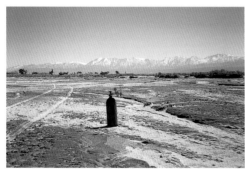

REPETITION

'Conceptual art' as a name first appeared in 1967 when Sol LeWitt published his 'Paragraphs on Conceptual Art' in *Artforum* in the summer of that year. LeWitt had been producing three-dimensional modular structures for some time (fig.30), and was about to embark on the wall drawings, which together have continued to constitute the core of his output. Neither type of work relies on conventions of handcraft or of traditional artistic authorship. The

constructions and drawings alike are fabricated by assistants working within the parameters of LeWitt's instructions. The opening of LeWitt's 'Paragraphs' has come to constitute the canonical statement of a general conceptualist approach: 'In conceptual art the idea or concept is the most important aspect of the work. When an artist uses a conceptual form in art, it means that all of the planning and decisions are made beforehand and the execution is a perfunctory affair.' As he declared, 'the idea becomes a machine that makes the art'. LeWitt was, however, careful to steer his notion of Conceptual art away from any suggestion of intellectual aridity, by offering qualifications such as 'Conceptual art is not necessarily logical', and 'The ideas need not be complex. Most ideas that are successful are ludicrously simple'. In fact for LeWitt, as he emphasised in the slightly later 'Sentences on Conceptual Art' of 1969, 'Conceptual artists are mystics rather than rationalists. They leap to conclusions that logic cannot reach. Rational judgements repeat rational

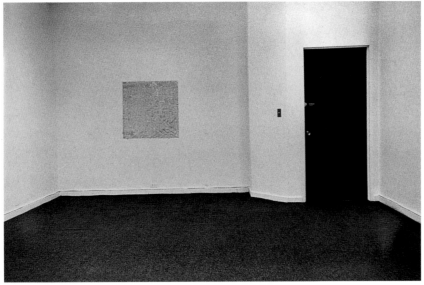

28
Lawrence Weiner

A 36″ x 36″ removal to the lathing or support wall of plaster or wallboard from a wall
1968

Installation photograph at the *January 5–31 1969* exhibition. The Siegelaub Collection and Archives at the Stichting Egress Foundation, Amsterdam

29
Keith Arnatt

Self-Burial (Television Interference Project)
1969

Nine photographs on board
Each panel 46.7 x 46.7 (18⅜ x 18⅜)
Tate

judgements. Illogical judgements lead to new experience.' This suspicion of the rational should not be surprising. After all, rationalism in the guise of planning, systems theory and scientific analysis, was being enlisted to prosecute the war in Vietnam. LeWitt's exhaustively repeated variations of lines, cubes and geometry in general seem at one level to do nothing so much as point to the insanity inherent in the obsessive pursuit of the rational. As Rosalind Krauss has argued, his strategies owe more to the maddeningly obsessive repetitions of Samuel Beckett's characters than to scientific rationalism (let alone to Pentagon planners).

This interest in repetitive, mantra-like strategies, pursued through and beyond obsession to a strangely still kind of meditation on time, constitutes a notable trend within the overall range of Conceptual art, a trend which, moreover, seems to have spanned the continents. LeWitt was working in America. Roman Opalka, an artist of Polish descent resident in France, began

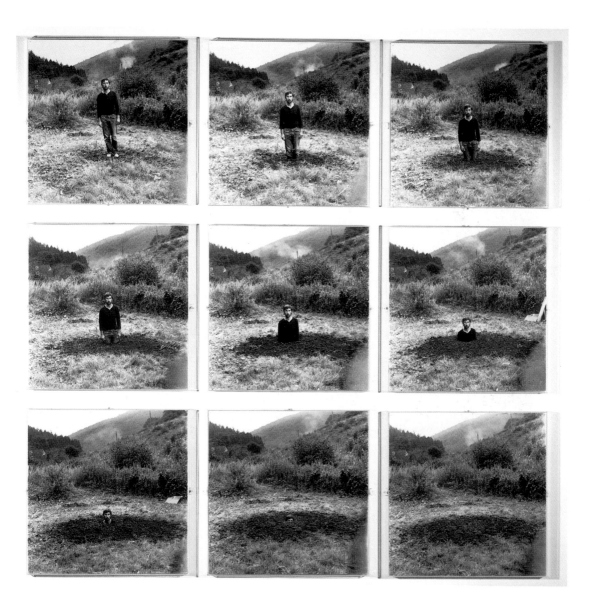

to paint a canvas in 1965. The canvas was painted black, 195 cm high and 135 cm wide. In the top left hand corner, with a brush laden with white paint, he inscribed the figure '1'. Next to it he inscribed '2'. The series *One to infinity* continues. By the time of the exhibition *Global Conceptualism* in 1999, Opalka's work featured there bore the title *1896176–1916613*. The artist speaks the numbers in Polish as he paints them, and the audio tape is a component of the work. The German artist Hanne Darboven, whose early career received support from LeWitt, began working with number sequences in the mid-1960s. Her installations characteristically took the form of shelves containing large volumes, the pages of which were sometimes covered in hand-written number sequences, or sometimes contained only one; as in the work consisting of all the days of a century: 365 volumes of 100 leaves each (fig.31). The pages of the first volume contain all the first-of-Januaries, the second, all the second-of-Januaries, and so on up to all the thirty-first-of-Decembers. In an exhibition at the Konrad Fischer gallery in Düsseldorf during 1971, one volume was displayed, open, in sequence, each day between 1 January and the end of December.

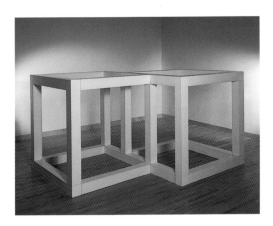

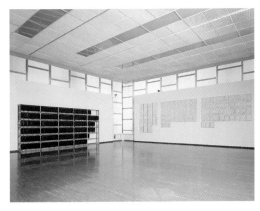

Best known of this 'genre', perhaps, are the date paintings of the Japanese artist On Kawara, begun on 4 January 1966. These too have continued, all slightly different, all hand painted, ever since, each being accompanied by a page from a newspaper of the day in question (fig.32). Related series by Kawara include postcards mailed to individuals in the art world recording the time at which he got up ('I got up ...'), or whom he met on a particular day ('I met ...'); and perhaps most poignantly, 'I am still alive – On Kawara'. This is the kind of thing that tries the patience of the sceptic. Ironically, in the face of such manifestations of Conceptual art, one can do little other than echo Michael Fried's claim made in respect of modernist painting: if someone doesn't feel they are 'superb paintings', then 'no critical arguments can take the place of feeling it'. What it means to feel convinced of the significance of an endless series of numbers, or a wall full of closed books that you know contain nothing but dates, or a minutely differentiated series of canvases, is a fair question. Insofar as there is an answer, it perhaps lies in the realm of our responses to the sublime, a sense of our limitation in the face of

30
Sol LeWitt

Two Open Modular Cubes/Half-Off 1972

Enamelled aluminium
160 x 305.4 x 233
(63 x 130¼ x 91¾)
Tate

31
Hanne Darboven

Books. A Century 1971

Installation photograph of books and bookshelf
Museum of Modern Art, Vienna

32
On Kawara

3 Date Paintings: Jan. 15, 1966 (This painting itself is January 15, 1966); Jan. 18, 1966 (I am this painting); Jan. 19, 1966 (From 123 Chambers St. to 405 E 13th St.) 1966

Liquitex on canvas
each 20.5 x 25.5 x 4
(8 x 10 x 1⅝)
Staatsgalerie Stuttgart

boundlessness, the oceanic; as well as of a certain humility when one's more or less frenetic, more or less trivial daily round fetches up against the stillness of a monastic sense of devotion, rendered only the more inaccessible by the complete absence of any validating deity. Conversely, what is evoked could just as well be taken as a kind of anti-sublime: something like the drudgery of assembly-line work, the endless cycle of production-as-production. What *is* it to centre your life around such a form of production, apparently pointless, apparently empty, eventually taking on its own justification (like life itself)? It is an open question whether we regard the work of these artists as close to being a kind of sacrifice, or a kind of self-imposed life sentence: as if Zen-like passivity meets a hollowed-out capitalist madness coming the other way.

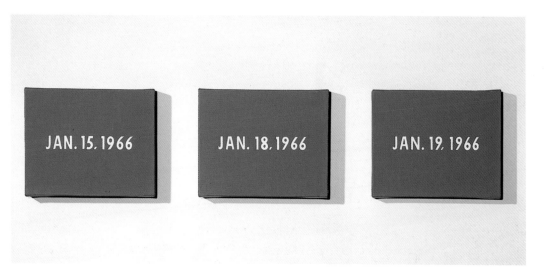

ANALYSIS

Joseph Kosuth's approach had a harder edge, forcing the pace in a series of works that have become icons of Conceptual art. In 1967 he exhibited the first of his *Investigations*, painting-sized works consisting not of visual imagery at all, but of words: negative photostats, white on black, of dictionary definitions of many of the key terms in the debate about the nature and status of modern art – 'meaning', 'object', 'representation', 'theory' (fig.1). As if in recognition of the still-present echo of painting and in a further radicalisation of his strategy, over the next few years Kosuth rejected the black ground-plane of the photostats and placed entries from the Thesaurus in sites previously not associated with art activity, such as hoardings in the city street, and the advertising columns of newspapers. Taken together, these projects raise the question of what it is to be confronted with a work of visual art that abjures the act of contemplation and insists instead on being *read*. That question haunts early Conceptual art. Modernist art was art to be looked at. Obstruct that, and at what point does what you are doing cease to be art? Or, at what point does what you are doing redefine the kinds of thing art can be? And if the latter, what follows?

VOLUME I NUMBER I MAY 1969

Art-Language

The Journal of conceptual art

Edited by Terry Atkinson, David Bainbridge,
Michael Baldwin, Harold Hurrell

Contents

Art-Language *is published three times a year by*
Art & Language Press 84 Jubilee Crescent, Coventry CV6 3ET
England, to which address all mss and letters should be sent.
Price 7s.6d UK, $1.50 USA All rights reserved

Printed in Great Britain

33
Art-Language,
vol.1, no.1, May 1969
Published in Coventry

Kosuth's subtitle, 'Art as Idea as Idea', points to the ambiguous nature of this tendency with respect to modernism. For the phrase is derived from Ad Reinhardt, whose paintings by their implacable logic represent a limit-case of artistic modernism. Pretty well ignored by the Greenbergian critics, Reinhardt performed the unlikely feat of combining intransigent left-wing politics with a ruthlessly pared-down abstract art. His finely tuned black paintings of the 1960s, almost but not quite monochrome — a characteristic revealed only by prolonged contemplation and effectively invisible in photographic reproduction — were conceived under an exclusive rubric: 'The one thing to say about art is that it is one thing. Art is art-as-art and everything else is everything else.' It was Reinhardt's unsentimental example, as much as the actual paintings to which it gave rise, that had an impact on those looking for a way beyond modernism without simply re-visiting what were by now the fairly well-trodden ways of avant-gardist, anything-goes gambits. Kosuth's *Investigations* received their most powerful theoretical support from the essay he published in the October 1969 edition of the journal *Studio International*, a text in which he acknowledged the influence of both Reinhardt and Duchamp. 'Art after Philosophy' has some claim to be the most extensive theoretical statement by a Conceptual artist made up to that point. In it, Kosuth asserts a distinction between art and aesthetics and rejects all conventional art since Duchamp. He also regards linguistic analysis as marking the end of traditional philosophy. The claim he arrives at is that art no longer requires the making of objects, that it is a propositional affair: that is, a proposition to the effect that *this* is a work of art. In effect, the work of art is an analytical proposition, a tautology, akin to 'A triangle has three sides'. As Kosuth writes, 'the "purest" definition of conceptual art would be that it is an inquiry into the foundations of the concept "art"'. Subsequent philosophically competent writers have been quick to point out that Kosuth's reasoning contained flaws. Peter Osborne indicated the inconsistency involved in claiming for a work of art the status of an *analytic* proposition while simultaneously arguing that it achieves such status only when presented in the *context* of art. Nonetheless, Kosuth's work represented a key point in the evolution of Conceptual art: simultaneously the *ne plus ultra* of modernist reductionism and an inquiry, *as art*, into what art was.

What it was to be an artist, and what it was that an artist was supposed to do or make, became unavoidable issues to confront, issues that required more than simple methods of 'making' or 'doing' in order to be adequately confronted. What seemed to be needed was a form of 'second-order', or 'meta-level' practice. Modernism had repressed the cognitive dimension of art. Now, in the ruins of modernism, language returned with a vengeance. The Art & Language group, initially based in Coventry, England, began to work through these ruins to see what might constitute a new form of critical practice, certainly different from what modernism had become, but no less critical of the avant-gardist 'Duchampian' legacy. Those who formed the first generation of Art & Language, Terry Atkinson, Michael Baldwin, David Bainbridge and Harold Hurrell, came together in 1966–7, though the name was not adopted until 1968, and the first issue of the journal *Art-Language* did not appear until the following year (fig.33). Among the most significant of their early works was a

long series devoted to investigating the implications of postulating ever more complex objects as possible candidates for the status 'work of art'. The important phrase in that last sentence is 'investigating the implications'. For the classically Duchampian strategy of 'nomination' had become, if not exactly discredited, then redundant, otiose. After a certain point, there is no 'point' in claiming another snow shovel, another pile of twigs on top of Ben Nevis,

34

When Attitudes Become Form

Installation photograph of exhibition at the Institute of Contemporary Arts, London, 1969 (with Victor Burgin's *Photopath* in the centre foreground)

35
Keith Arnatt

Trouser Word Piece
1972

Photograph and text
Each panel
100.5 x 100.5
(39½ x 39½)
Tate

36
John Hilliard

Camera Recording its own Condition
(7 apertures, 10 speeds, 2 mirrors)
1971

Photographs on card on Perspex
216.2 x 183.2
(85⅛ x 72⅛)
Tate

Keith Arnatt
TROUSER – WORD PIECE

'It is usually thought, and I dare say usually rightly thought, that what one might call the affirmative use of a term is basic - that, to understand 'x', we need to know what it is to be x, or to be an x, and that knowing this apprises us of what it is **not** to be x, not to be an x. But with 'real' it is the **negative** use that wears the trousers. That is, a definite sense attaches to the assertion that something is real, a real such-and-such, only in the light of a specific way in which it might be, or might have been, **not** real. 'A real duck' differs from the simple 'a duck' only in that it is used to exclude various ways of being not a real duck - but a dummy, a toy, a picture, a decoy. &c.; and moreover I don't know **just** how to take the assertion that it's a real duck unless I know **just** what, on that particular occasion, the speaker had it in mind to exclude (The) function of 'real' is not to contribute positively to the characteri- sation of anything, but to exclude possible ways of being **not** real - and these ways are both numerous for particular kinds of things, and liable to be quite different for things of different kinds. It is this identity of general function combined with immense diversity in specific applica- tions which gives to the word 'real' the, at first sight, baffling feature of having neither one single 'meaning,' nor yet ambiguity, a number of different meanings.'
John Austin, 'Sense and Sensibilia.'

I'M A REAL ARTIST

another brainwave, as a work of art. Atkinson and Baldwin (the name 'Art & Language' not yet being assigned as 'author' of these early works) postulated such 'objects' in rather more systematic fashion, in ascending orders of complexity, to raise questions about the ontology of art. The items in question included: a column of air (i.e. matter, in gas-state); Oxfordshire (i.e. an irregular, spatially bounded area; but what of the third dimension? How *deep*?); the French Army (i.e. a complex entity made up of various men and machines,

continually changing its constituent parts yet maintaining its identity over time); the claim that the as-yet unbuilt wall between two houses, numbers 25 and 26 Sunnybank, *is* an art object (i.e. a future conditional); and, as a kind of limit-case, the claim that the essay investigating the claim is itself an art object.

In Britain, 'analytical' Conceptual art became a powerful force in the late 1960s and early 1970s, embracing the work of considerable numbers of artists. Exhibitions took place in London every year, including the international survey *When Attitudes Become Form* in 1969 (fig.34) as well as more locally focused examples such as *Idea Structures* in 1970, the Lisson Gallery *Wall Show* in 1971, the *Survey of the Avant Garde* in 1972 and the Hayward Gallery's major *New Art* in the same year. In addition to exhibitions, there was a wide variety of journals, some commercially published, others informally distributed. These ranged from *Art-Language*, first published in Coventry in May 1969, to the London-based *Control* and *Frameworks*, and various college-based examples by an emerging generation. They included *Analytical Art*, the Newport Group series, and slightly later in the

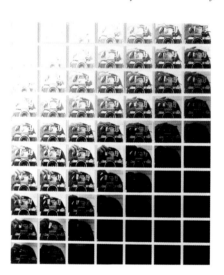

mid-1970s *Issue*, *Ratcatcher* and *Ostrich*, which related to an Art & Language-based initiative aimed at providing sites for critical work within the institution of art education under the umbrella title *School*. Much of this later work began to constitute a critique of the art institution itself, and in the second half of the 1970s to move beyond art into a wider network of radical cultural-political practice, which will be discussed in the next chapter. But in the earlier phase, a wide range of text and photo-based work appeared by Art & Language, Keith Arnatt, John Stezaker, Victor Burgin, Michael Craig-Martin and others. Much of this raised questions about the nature of the work of art, the role of the artist and the role of the spectator. Arnatt took a resoundingly analytical text by the Oxford philosopher J.L. Austin to analyse and simultaneously ironise claims about what a 'real' artist was (fig.35). Burgin's wall-mounted textual instructions virtually compelled the viewer to become aware of the process in which he was, at that very moment, engaged. John Hilliard's *Camera Recording its own Condition* invites a wider self-consciousness about visual representation, and in particular the claims of objectivity and 'factualness' that surrounded photography (fig.36).

PHOTO-TEXT

Photography had from the first been a key device for Conceptual artists, often being used in conjunction with texts of varying kinds. In fact Jeff Wall has claimed that it was 'essential' to Conceptual art's achievement. His argument is that for the critical avant-garde it was 'no longer necessary to separate oneself from the people through the acquisition of skills and sensibilities rooted in craft-guild exclusivity'. More than that: 'in fact it was absolutely necessary not to do so, but rather to animate with radical imagination those common techniques and abilities made available by modernity itself'. Foremost among these was photography, and not 'art-photography', but mass, amateur

photography. For Wall, the important precursor here was Ed Ruscha, who had begun his series of photobooks as early as 1963 with *Twenty-Six Gasoline Stations* (fig.37), continuing with *Some Los Angeles Apartments*, and *Every Building on Sunset Strip*. Photography increasingly became used to document the variety of activities and performances that formed an ever more influential complement to more narrowly 'analytical' Conceptual art. Activities as diverse as those by Gilbert and George and Richard Long in Britain (fig.38), and Robert Smithson and Bruce Nauman in the United States all relied on the photograph to establish their presence in the field, either in exhibitions or in the pages of books and magazines. The status of all these activities was markedly unstable at the time of their first appearance. Nauman has commented on how he spent a lot of time reassessing what it was that artists were supposed to do, and that his early work was made out of just that activity: spilled coffee, pacing around the studio, and the like (fig.39). As he said, the only way to find out whether it was art was to do it. Nauman admitted that there was a great deal of confusion as it became apparent that art 'doesn't require being able to draw, or being able to

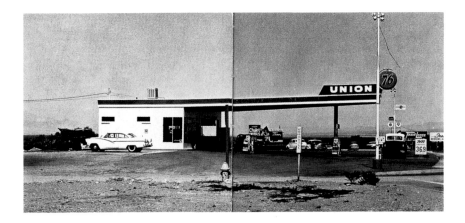

paint well or know colours, it doesn't require any of those specific things that are in the discipline, to be interesting'. And yet without skill and accomplishment of *some* kind, there would be nothing to communicate. As Nauman put it, what was interesting was 'the edge between' the two conditions.

In the mid-1960s, Dan Graham was producing works that at the time had an extremely unstable identity, were hardly 'art' at all, but which have subsequently been accorded exemplary status in the Conceptual canon. Graham was engaged in the usual round of writing and reviewing, the hinterland of poetry and art that constituted life in the New York avant-garde, forever struggling to get his pieces published. *March 31st 1966* consisted of eleven 'lines' recounting the distance from the edge of the known universe to Graham's own retina, via the distances to Washington DC, to Times Square in New York, to Graham's own front door, and the sheet of paper on the typewriter. The mixture of flat literalism and quirkily imaginative meditation on the process of looking, or the process of writing, is characteristic: the economy of Graham's means belying the sweep of the idea. In two nicely judged inversions of consumer culture

regarding sex and shopping, Graham took advertising space and placed a medical text on male detumescence and a supermarket check-out slip in, respectively, the *New York Review of Sex* and *Harper's Bazaar*.

In 1966 he also produced the ambitious *Homes For America*, a kind of photo-text essay likewise intended to appear in a glossy magazine such as *Harper's Bazaar* (fig.40). The project fell through (as many of Graham's projects seem to have done) and a version finally appeared in mangled form in *Arts* magazine in the December 1966/January 1967 issue. The piece is now usually reproduced, as it is here, as a two-part print in Graham's original format. Neither art-print nor mere magazine article, the piece remains hard to categorise. It consists of a series of thirty-four similarly sized 'blocks' in six vertical columns, three to a 'page'. Some of the blocks consist of Graham's text, a studiedly deadpan description of American 'tract-housing', somewhere between a brochure and a sociological survey. Other blocks include different kinds of text: a list of the range of housing designs available ('A: The Sonata, B: The Concerto ...'); a list

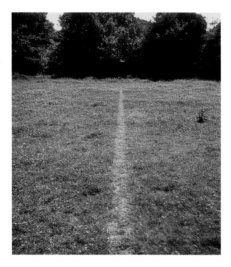

37
Ed Ruscha

Union, Needles, California (from Twenty-Six Gasoline Stations) 1963

The Siegelaub Collection and Archives at the Stichting Egress Foundation, Amsterdam

38
Richard Long

A Line Made by Walking, England 1967

Anthony d'Offay Gallery, London

of possible exterior colours ('5: Lawn Green ... 7: Coral Pink'); the results of a survey of male and female customers' likes and dislikes in the colour range; an alphabetically coded summary of the variations possible among the different house styles if built in blocks of eight (AABBCCDD, AABBDDCC, AACCBBDD ...). Other 'blocks' in Graham's print are visual in nature, mostly photographs, and mostly colour. Some are of serried ranks of houses. Some are of exterior details, such as steps leading up to doors; some of interior details such as a bedroom. Others are of discount stores selling the consumer durables to go into the 'Homes For America'. What Graham has in effect done is to take the modular arrangement associated with the then leading avant-garde art style, Minimalism, and transfer it to the page. But in doing so he applies two different kinds of inflection that have the effect of conferring a new identity on the piece. One is to treat words and pictures as equivalents. The second is emphatically to open the modular format of Minimal sculpture out onto the wider modernity, to open the apparently most hermetic of modern art movements out onto American social life. One of the features of successful Conceptual art is how a major shift is made with the apparent minimum of means, as if doing almost nothing can, if the circumstances are right, turn the world on its axis. The historian Thomas Crow has argued that the critical import of Graham's apparently slight intervention goes beyond mapping avant-garde form onto suburban existence. Rather, by doing so, by revealing the industrialised and manufactured condition even of contemporary domestic life, Graham brings out the essential reason behind the crisis of modernism. The

rhetoric of self-expression, the valorisation of individual feeling, above all of autonomy itself, simply do not accord with the form of contemporary life, wherein subjectivity itself is mass-produced. In effect, that is to say, modernism is ideological with respect to modernity. It conceals the absence of its own values from lived social life. Rather than offering a genuine transcendence of contingency, institutionalised modernism functions as part of the ideological mask of a manipulative and disabling social order.

It goes without saying that no art can escape the framing conditions of its time. But the feeling was widespread among younger artists that the price of medium-specificity, and indeed of the related division of labour between modernist artist and modernist critic (painters *painted*), contributed to an art that had become affirmative of – rather than critical of – its social matrix. Robert Smithson, best known for his large-scale earthworks of the early 1970s, also produced text/photograph pieces around this time. Smithson's influence was powerful and fundamental to a good deal of early Conceptual art, though he himself came to dislike it and to regard the restriction to language as a medium as a form of idealism. In *The Monuments of Passaic* (1967), Smithson combined narrative, quotation and photography in a many-layered but disarmingly limpid account of a day's activity. He tells the story of purchasing a film and heading out by bus from New York with his Instamatic camera to his birthplace, the industrial town of Passaic in New Jersey. There he proceeds to photograph industrial sites as if they were anti-heroic monuments to

a dying industrial modernity (fig.41). The banal photographs and the flat descriptive text, encompassing the specification from the box of film as well as a smuggled-in critique of modernist painting in the guise of a commentary on a newspaper review of an Olitski exhibition that he reads on the bus, all combine to produce a multiply transgressive work: transgressive of the very protocols Smithson's generation had come to find limiting in modernism. Smithson concisely articulated the perspective informing a wide range of loosely 'conceptual' art practices in a slightly later text of 1972, written on the occasion of the Documenta exhibition in Germany. *Documenta V* was an enormous exhibition that has some claim to represent the high-water mark of early Conceptual art, the point at which it moved from being an oppositional, critical force, to a hegemonic power on the international art scene. Smithson's contribution included a short text on the theme of 'cultural confinement', noting how if the artist failed to look beyond the existing institutions of culture, then the avant-garde artist no less than the modernist-conservative

turned into a laboratory rat 'doing his tough little tricks' in the place given to him to do them. As Smithson averred, in a phrase that touches the ethos of the whole critical-conceptual nexus, 'It would be better to disclose the confinement rather than make illusions of freedom.'

INDEX

By the early 1970s, the very openness of the avant-garde situation threatened to become its own confinement. Addressing this condition became the main preoccupation of the much-expanded Art & Language group, active now on both sides of the Atlantic. Philip Pilkington and Dave Rushton had joined the English group. Joseph Kosuth had become American editor in 1970, and Ian Burn and Mel Ramsden had amalgamated their own 'Society for Theoretical Art' into the wider Art & Language, which had come to comprise around thirty individuals. In 1970, Burn and Ramsden wrote that since an art object by now 'might conceivably be anything on the face of this planet', then 'it would be dumb to insist on nominating an analytic art construct (i.e. this paper) as an "artwork"'. Rather, it was time for Conceptual artists to turn their concern not to 'the proliferation of designated signifieds' but to the 'semiotic mosaic' from which meaning was derived. What really mattered was the 'fundamental changes' in the 'conceptual sign-structure of the continuum itself'. The language is hesitant, but it grapples with a real problem. How was the 'continuum', the system, the structure-as-whole, itself to be made the content of the work? The Art & Language *Index 01* produced for the 1972 *Documenta V* exhibition was an ambitious attempt to go beyond the various conceptualist strategies of 'nomination' that had grown out of the Duchampian readymade tradition, beyond indeed specific 'conceptual artworks' as such, towards the production of a kind of generic work (fig.42).

The *Index* challenged convention on all fronts: the nature of the artist (it was collectively produced); the nature of the work (it consisted of objects and texts); and the nature of the spectator (the work was to be *read*). The installation consisted of a group of eight filing cabinets containing 87 texts culled from the *Art-Language* journal as well as other published and unpublished material by members of the group. On the surrounding walls, an Index was displayed that allowed each text to be tabulated against every other. This comparison was made according to three relations: 'compatible' (+), 'incompatible' (−), and 'transformation' (T). This third relation is clearly the most problematic, even as it seems to hold out the most potential for interest. The accompanying 'Instructions for using the Index' state that it means 'impossible to compare without some transformation of the grounds of comparison'. The point seems to be akin to that contained in another characteristically elliptical Art & Language claim, adopted from the philosopher Rudolf Carnap: that 'how one does one's singling out determines what one singles out'.

Taken out of context, the significance of these remarks might not be immediately obvious, but when unpacked, they can be seen to reflect a basic shift in the cultural priorities of the period. What seems to have happened was a widely felt change in priorities that had an impact across the humanities, and

39
Bruce Nauman

Coffee Thrown Away Because It Was Too Cold 1967

Edition of eight
50.8 x 61 (20 x 24)
from *Eleven Colour Photographs*
1966/7–1970
Portfolio of eleven colour photographs
Courtesy of Sperone Westwater, New York

FOLLOWING DOUBLE PAGE:
40
Dan Graham

Homes for America 1966–7

Two panels: printed text and photographs mounted on board each 101 x 76 (39¾ x 29⅞)
Marian Goodman Gallery, New York

Homes for America

D. GRAHAM

Belleplain
Brooklawn
Colonia
Colonia Manor
Fair Haven
Fair Lawn
Greenfields Village
Green Village
Plainsboro
Pleasant Grove
Pleasant Plains
Sunset Hill Garden

Garden City
Garden City Park
Greenlawn
Island Park
Levitown
Middleville
New City Park
Pine Lawn
Plainview
Plandome Manor
Pleasantside
Pleasantville

"The Serenade"- Cape Coral unit, Fla.

Set-back, Jersey City, New Jersey

Large-scale 'tract' housing 'developments' constitute the new city. They are located everywhere. They are not particularly bound to existing communities; they fail to develop either regional characteristics or separate identity. These 'projects' date from the end of World War II when in southern California speculators or 'operative' builders adapted mass production techniques to quickly build many houses for the defense workers over-concentrated there. This 'California Method' consisted simply of determining in advance the exact amount and lengths of pieces of lumber and multiplying them by the number of standardized houses to be built. A cutting yard was set up near the site of the project to saw rough lumber into those sizes. By mass buying, greater use of machines and factory produced parts, assembly line standardization, multiple units were easily fabricated.

Each house in a development is a lightly constructed 'shell' although this fact is often concealed by fake (half-stone) brick walls. Shells can be added or subtracted easily. The standard unit is a box or a series of boxes, sometimes contemptuously called 'pillboxes.' When the box has a sharply oblique roof it is called a Cape Cod. When it is longer than wide it is a 'ranch.' A

The logic relating each sectioned part to the entire plan follows a systematic plan. A development contains a limited, set number of house models. For instance, Cape Coral, a Florida project, advertises eight different models:

A The Sonata
B The Concerto
C The Overture
D The Ballet
E The Prelude
F The Serenade
G The Noctune
H The Rhapsody

Two Entrance Doorways, 'Two Home Homes', Jersey City, N.J.

Center Court, Entrances, Development, Jersey City, N. J.

Housing Development, rear view, Bayonne, New Jersey

two-story house is usually called 'colonial.' If it consists of contiguous boxes with one slightly higher elevation it is a 'split level.' Such stylistic differentiation is advantageous to the basic structure (with the possible exception of the split level whose plan simplifies construction on discontinuous ground levels).

There is a recent trend toward 'two home homes' which are two boxes split by adjoining walls and having separate entrances. The left and right hand units are mirror reproductions of each other. Often sold as private units are strings of apartment-like, quasi-discrete cells formed by subdividing laterally an extended rectangular parallelopiped into as many as ten or twelve separate dwellings.

Developers usually build large groups of individual homes sharing similar floor plans and whose overall grouping possesses a discrete flow plan. Regional shopping centers and industrial parks are sometimes integrated as well into the general scheme. Each development is sectioned into blocked-out areas containing a series of identical or sequentially related types of houses all of which have uniform or staggered set-backs and land plots.

In addition, there is a choice of eight exterior colors:
1 White
2 Moonstone Grey
3 Nickle

LAWN GREEN

4 Seafoam Green
5 Lawn Green
6 Bamboo
7 Coral Pink
8 Colonial Red

As the color series usually varies independently of the model series, a block of eight houses utilizing four models and four colors might have forty-eight times forty-eight or 2,304 possible arrangements.

Dan Graham

Housing Development, front view, Bayonne, New Jersey

Interior of Model Home, Staten Island, N.Y.

Each block of houses is a self-contained sequence — there is no development — selected from the possible acceptable arrangements. As an example, if a section was to contain eight houses of which four model types were to be used, any of these permutational possibilities could be used:

Bedroom of Model Home, S.I., N.Y.

AABBCCDD	ABCDABCD
AABBDDCC	ABDCABDC
AACCBBDD	ACBDACBD
AACCDDBB	ACDBACDB
AADDCCBB	ADBCADBC
AADDBBCC	ADCBADCB
BBAADDCC	BACDBACD
BBCCAADD	BCADBCAD
BBCCDDAA	BCDABCDA
BBDDAACC	BDACBDAC
BBDDCCAA	BDCABDCA
CCAABBDD	CABDCABD
CCAADDBB	CADBCADB
CCBBDDAA	CBADCBAD
CCBBAADD	CBDACBDA
CCDDAABB	CDABCDAB
CCDDBBAA	CDBACDBA
DDAABBCC	DACBDACB
DDAACCBB	DABCDABC
DDBBAACC	DBACDBAC
DDBBCCAA	DBCADBCA
DDCCAABB	DCABDCAB
DDCCBBAA	DCBADCBA

'Discount Store', Sweaters on Racks, New Jersey.

The 8 color variables were equally distributed among the house exteriors. The first buyers were more likely to have obtained their first choice in color. Family units had to make a choice based on the available colors which also took account of both husband and wife's likes and dislikes. Adult male and female color likes and dislikes were compared in a survey of the homeowners:

'Like'

Male	Female
Skyway	Skyway Blue
Colonial Red	Lawn Green
Patio White	Nickle
Yellow Chiffon	Colonial Red
Lawn Green	Yellow Chiffon
Nickle	Patio White
Fawn	Moonstone Grey
Moonstone Grey	Fawn

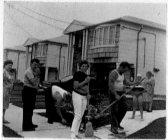

Two Family Units, Staten Island, N.Y.

'Dislike'

Male	Female
Lawn Green	Patio White
Colonial Red	Fawn
Patio White	Colonial Red
Moonstone Grey	Moonstone Grey
Fawn	Yellow Chiffon
Yellow Chiffon	Lawn Green
Nickle	Skyway blue
Skyway Blue	Nickle

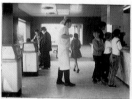

Car Hop, Jersey City, N.J.

A given development might use, perhaps, *four* of these possibilities as an arbitrary scheme for different sectors; then select four from another scheme which utilizes the remaining four unused models and colors; then select four from another scheme which utilizes all eight models and eight colors; then four from another scheme which utilizes a single model and all eight colors (or four or two colors); and finally utilize that single scheme for one model and one color. This serial logic might follow consistently until, at the edges, it is abruptly terminated by pre-existent highways, bowling alleys, shopping plazas, car hops, discount houses, lumber yards or factories.

'Split-Level', 'Two Home Homes', Jersey City, N.J.

'Ground-Level', 'Two Home Homes', Jersey City, N.J.

Although there is perhaps some aesthetic precedence in the row houses which are indigenous to many older cities along the east coast, and built with uniform façades and set-backs early this century, housing developments as an architectural phenomenon seem peculiarly gratuitous. They exist apart from prior standards of 'good' architecture. They were not built to satisfy individual needs or tastes. The owner is completely tangential to the product's completion. His home isn't really possessable in the old sense; it wasn't designed to 'last for generations'; and outside of its immediate 'here and now' context it is useless, designed to be thrown away. Both architecture and craftsmanship as values are subverted by the dependence on simplified and easily duplicated techniques of fabrication and standardized modular plans. Contingencies such as mass production technology and land use economics make the final decisions, denying the architect his former 'unique' role. Developments stand in an altered relationship to their environment. Designed to fill in 'dead' land areas, the houses needn't adapt to or attempt to withstand Nature. There is no organic unity connecting the land site and the home. Both are without roots — separate parts in a larger, predetermined, synthetic order.

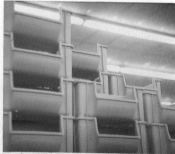

Kitchen Trays, 'Discount House', New Jersey.

ARTS MAGAZINE/December 1966-January 1967

Dan Graham

indeed beyond. The effects were registered in histories of art, of science and of literature, in the emergent field of cultural studies and in the social sciences, as well as in the practice of art itself. Two aspects in particular are noteworthy. By no means logical bedfellows, they were nonetheless historically powerfully connected. On the one hand the period witnessed the beginnings of the impact of French theory on English-language cultural studies. It is not overstating the case to say that forms of analysis indebted to Ferdinand de Saussure's theory of language via the work of Roland Barthes became dominant across the arts. The terminology of 'signifiers' and 'signifieds', 'signs', 'semiotics' (and later a host of others from 'deconstruction' to 'difference') simply became the *lingua franca* of cultural debate. Accompanying this there was a leaning towards sociologism, which involved a shift in the focus of interest from 'text' to 'context'. Thus the social history of art mounted a critique of modernism's exclusive focus on the visual *effects* of the work of art itself, emphasising instead the constellation of social *causes* out of which it was made. At this time there also appeared a so-

called 'sociology of knowledge'. And particularly significant was a development in the philosophy of science associated with T.S. Kuhn's notion of 'paradigm revolutions'.

Kuhn argued that scientific knowledge did not progress cumulatively, brick by brick, truth by truth, but through a series of leaps. Certain crucial breakthroughs would set an agenda that subsequent scientists then continued to explore. Eventually however, anomalous experimental results would appear, which over time began to threaten the system's overall coherence. After a period of uncertainty during which the system underwent fundamental questioning, a 'paradigm shift' would occur. A new agenda would emerge, and scientific practice would be reconfigured to provide experimental answers to a new set of questions. Kuhn's theory thus introduced a measure of relativism into the field of scientific knowledge. As such, it was immediately subject to question and qualification in the philosophy of science itself because of the powerful connection between scientific knowledge and the concept of 'truth'. However, in the cultural field Kuhn's theoretical revision had a pronounced impact, seeming as it did to lend support to an emerging, and pervasive, relativism of values.

Art & Language tended to be sceptical of the fashion for French theory, instead drawing heavily on the analytical tradition in philosophy. But Kuhn's theory of paradigm shifts seemed to be instantly applicable to art, a liberating device to think through the change that Conceptual art was making to the foundational assumptions of previously existing modern art. An essay by Atkinson and Baldwin, published in *Studio International* in 1970, explored the consequences of Conceptual art's shift away from what was defined as the

41
Robert Smithson

The Fountain Monument – Bird's Eye View
from *Monuments of Passaic* 1967

Photograph
The National Museum of Contemporary Art, Oslo

42
Art & Language

Index 01 1972

Photograph of installation at the Gallerie Nationale du Jeu de Paume, Paris, 1994

'MCPOP': the 'material-character, physical-object paradigm' of art. The recognition encoded in the Art & Language proposition is that the criteria one employs to sort out the world will have a determining effect on the kind of world one is able to sort out. The world – or more particularly, art – is not divided into natural kinds (e.g. 'art-object/not-art-object'); rather, our language, and by extension the conceptual structures we employ, help formulate what we see *as* something (*as* art; *as* art criticism; *as* politics). The 'transformational' relation in the *Index* testifies to a similar perception. It is not enough to say that A is compatible with B, or incompatible with X; one has to raise questions about, interrogate, and in the end transform the very grounds upon which such things as comparisons or identity ascriptions are made. Item 1 may be a work of art, Item 2 may be a piece of art criticism, Item 3 may be a proposition of philosophy, but transform the discipline definitions on which

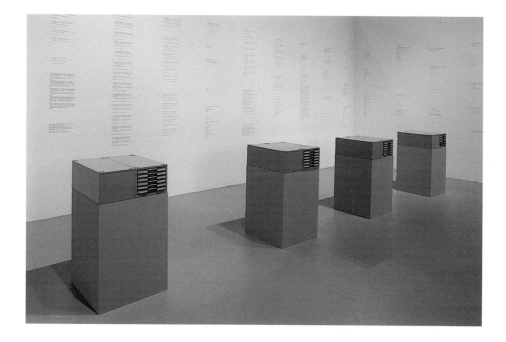

those comparisons depend, and a different map of the terrain may emerge. In this case, perhaps an on-going art practice *can* be constituted out of the conversation of its participants, a collective 'theoretical practice' informed by a variety of philosophical, linguistic or even popular-cultural resources. As such, it would neither have to issue in finite objects for purposes of aesthetic delectation, nor be regarded as the product of an individual 'artistic' author. This is not to say that a transformed sense of the aesthetic might not remain open as a possibility. But it is to conceive of art as potentially a kind of critical, cognitive, above all, social practice that can enable the achievement of a critical self-consciousness in the world, and perhaps even influence the production of such a world. It goes without saying, however, that such a transformation *in history* requires more than modelling in art.

5

Politics and Representation

There have been several examples in the history of modern art of projects that
have attempted to imagine a transformed world. The most obvious are those
associated with the Soviet Constructivists of the 1920s, though there have been
others. But international capitalism was not consigned to history after the
Bolshevik October. Neither did the radicalism of the late 1960s and 1970s issue
in any fundamental political transformation. Writing as early as 1973, Lucy
Lippard lamented the absorption of the radical impulses of Conceptual art:
the way that even sheets of typewritten paper were being exchanged as
commodities on the art market, and that leading conceptualists had built
successful careers within the existing market structure. Ian Burn wrote in 1981
that 'perhaps the most significant thing that can be said to the credit of
Conceptual art is that it *failed*'. In that sense, how could it not, given the
generalised failure of the 'counter-culture' of which it was a part? And yet
despite the bedrock of capitalism remaining in place, history does move; social
and cultural change occurs. In a more limited sense, Conceptual art was part of
a significant change. One of the key features of the development of Conceptual
art in the 1970s was its increasing politicisation. For some, including Burn, this
meant that Conceptual art was *transitional*: transitional out of art as such, into a
wider field of engaged cultural practice beyond the structures of the art world,
in publishing, television, community or trade union-related activity. But for
others, the developing sense of a politics of representation issued in a change to
the conception of art itself, a change summed up in Hal Foster's remark that
the postmodernist artist was less a producer of objects than a manipulator of

signs – one who engaged critically with the broad field of representation.

It sometimes appears that everything about Conceptual art is problematic and debatable. Certainly, care is required over the question of conceptualism's political dimension. It is a significant question, for example, just how *overt* an activity has to be to be 'political'. A refusal of the stereotypes of what an art practice could be, may itself arguably count as 'political'. Yet, in the English-speaking world, Conceptual art does not seem expressly to have addressed 'political' issues as such until the early 1970s. Yet, art world debate *was* becoming increasingly politicised in the late 1960s, and beyond the Anglophone orbit some kindred types of work *did* embrace an explicit politics from an early date.

EUROPE

In Europe, France and Italy experienced social convulsions. These climaxed in the May Days of 1968 in Paris, and the more extended Hot Autumn of 1969 in

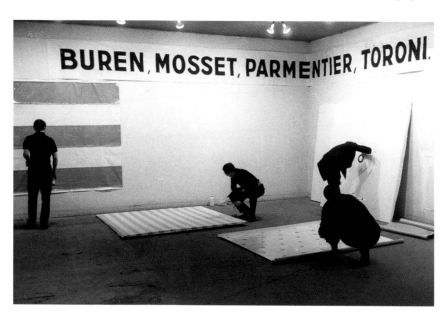

43
Daniel Buren, Olivier Mosset, Michel Parmentier and Niele Toroni

Manifestation No.1: Buren, Mosset, Parmentier, Toroni
1967

Salon de la Jeune Peinture, Musée d'Art Moderne de la Ville de Paris

Italy. In France the Situationists had developed a conception of modern consumer society that explained the role played by ideological conformity to dominant values in maintaining the system. This suggested a shift in the focus of revolutionary activity away from the traditional Marxist orientation on economics and politics, towards a concentration on culture and ideology. During the 1960s, the Situationists came to play a significant role in the radicalisation of French students in the build-up to 1968. Despite initially working with artists such as Asger Jorn, however, the group came to abjure art as a feasible site of revolutionary struggle. Film was a more powerful cultural weapon, as in the work of Jean-Luc Godard. For the Situationists' philosophical mentor Guy Debord, art was an irredeemable constituent of the 'society of the spectacle', its myths of individualism and self-expression part of what kept the masses in thrall to consumption, rather than a valid way out. Nonetheless, there were artists who carried forward a radical programme

embodying aspects of Situationist cultural polemic in the field of the visual arts. Daniel Buren was among those who distanced himself from the term 'Conceptual art' but whose activities certainly fit within a broader oppositional current. In consort with Olivier Mosset, Michel Parmentier and Niele Toroni, Buren staged a demonstration at the Salon de la Jeune Peinture on 3 January 1967. The four artists had each adopted an impersonal style, Buren's consisting of vertical red and white stripes, Mosset's of a black circle on a white ground, Parmentier's of horizontal bands of grey and white, and Toroni's of square imprints made by a standard-sized brush coated in blue paint (fig.43). On the next day, the artists removed their work, replacing it with a banner reading *Buren, Mosset, Parmentier, Toroni n'exposent pas* (Buren, Mosset, Parmentier, Toroni are not exhibiting). In a pamphlet distributed at the same time, they affirmed 'We are not painters', offering a variety of reasons to do with conventional assumptions about composition, the representation of objects, spiritual compensation, and the way in which painting conferred aesthetic value on a range of factors including 'eroticism, the daily environment ... psychoanalysis and the war in Vietnam'.

The point was to draw attention not to the paintings themselves, but to the expectations induced by the art context. Buren in particular went on to invert the normal relationship between an exhibition space and the work of art. Conventionally, a gallery will remain more or less the same while the works displayed in it will change. Buren, however, maintained his trademark vertical coloured stripes through a multiplicity of situations, ranging from galleries to the exteriors of buildings, to billboards, to the pages of a magazine (fig.44). The object of the work is to function through a set of negations – negation of formal interest, negation of aesthetic appeal, negation of emotional content, and so on, and to transfer the attention normally devoted to the work of art onto its surrounding location.

Buren's work thus marks an early instance of what was to become a central feature of politicised Conceptual art, the critique of the institution – although whether that strategy can be said to remain viable is another matter. Certainly, by the time he was invited by the French state in 1986 to redesign the courtyard of the Palais Royale in Paris with his characteristic stripes, the critical virtue that attached to Buren's practice *c*.1968 cannot but be felt to have evaporated. Hindsight notwithstanding, the point is that the role of institutions was beginning to become a subject of critical study. In the late 1960s, the French Marxist philosopher Louis Althusser introduced the notion of the 'ideological state apparatus' as part of an attempt to understand the way in which both formal and informal institutions, such as education and the family, contributed to the reproduction of existing relations of production. The work of Michel Foucault, in particular, became concerned with the relationship of knowledge and power in society. Artists rapidly began to apply these insights to the function of art itself and its supporting institutions, principally the market and the museum.

An early work of art that took up the question of the museum was Marcel Broodthaers's *Musée d'Art Moderne, Département des Aigles* (fig.45). Broodthaers was a Belgian poet who had turned to art in the mid-1960s, producing an eclectic

range of objects, photographs, books and films. Begun in 1968 and shown in its final form at *Documenta V* in 1972, the device of the fictional 'Museum of Eagles' was in essence simple. Beginning with postcards of nineteenth-century academic paintings, Broodthaers painstakingly amassed a repertoire of images drawn from popular culture and advertising. Selecting the eagle allowed for a myriad of representations connoting the rich cultural mythology surrounding

45
Marcel Broodthaers

Musée d'Art Moderne, Département des Aigles, Section Publicité 1972

Installation at *Documenta V*, Kassel, Germany

46
Janis Kounellis

Untitled (Twelve Horses) 1969

Installation at Galleria L'Attico, Rome

47
Mario Merz

Che Fare? (What is to be done?) 1969

Metal tubes, glass, plaster, bunches of twigs
150 x 250 x 320 (59 x 98⅜ x 136)
Archivio Merz

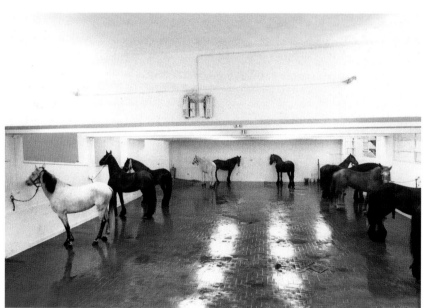

the feathered predator: national symbol, martial symbol, symbol of fortitude, of perception, metaphor for genius, etc. By collecting together these various representations, Broodthaers produced, in effect, a second-order representation – not of a lot of birds, but of a classificatory system at work. Of course, eagles connote various characteristics, as we have seen: valour, power, etc. They also

demonstrate, through the medium of academic painting, how art recycles ideology. But the point is also that it could have been *anything*: that classificatory systems impose order and structure on their contents. Deconstructing the museum has subsequently become a well-worn strategy of cultural studies, but Broodthaers' parody, which owes more to Borgés than to social science, has the advantage of a sense of wit beyond many of his more earnest successors, as if his intervention were saved from worthiness precisely by verging on the arbitrary. In a text accompanying the Documenta installation, Broodthaers wrote: 'This museum is a fiction. In one moment it plays the role of a political parody of artistic events, in another that of an artistic parody of political events. Which is in fact what official museums and institutions like Documenta do as well. With one difference, that a fiction enables you to grasp both reality and at the same time those things that reality hides.'

In Italy, the critic Germano Celant brought together a newly emergent avant-garde under the banner of Arte Povera in 1967. The name, which derived from the theatre of the Polish director Jerzy Grotowski, connotes a criticism of wealth. Driven by a scepticism of the traditional media of 'fine' art, the Italian

avant-garde embraced a wide and heterogeneous range of materials out of which to make art: bricks, stones, wood, cardboard, paper. As Celant wrote, 'animals, vegetable and minerals take part in the world of art'. As if in confirmation, for his installation in Rome in 1969, Jannis Kounellis stabled twelve horses in the gallery (fig.46). All of this is commensurate with Antiform-type developments in the contemporary Anglo-American art world. Given the Italian situation, however, it is unsurprising to find an overtly political edge to some of the art. Mario Merz's igloos bear upon that aspect of Arte Povera theory that extols the nomadic and non-Western at the expense of Western consumer capitalism. In one case, the phrase 'What is to be done?' was threaded through the tree branches over which an igloo was constructed (fig.47). This was the title of Lenin's pamphlet of 1902 in which he discussed the role of intellectuals in the revolutionary party. Given the predominantly anarchist currents running through the Italian left, no less critical of the official Communist party than of consumer capitalism itself, Merz's gesture may signify a broader cultural radicalism than traditional left politics *per se*. Alighiero Boetti produced a series of copper etchings of maps of countries at war, including Libya, Israel and Ireland. Michelangelo Pistoletto's *Zoo* collective embodied anarchistic theatricality in a variety of street performances. Celant regarded the overall tendency of the work as representing 'an asystematic way of existence in a world in which the system is everything'. Indeed, writing with characteristic hyperbole, he rhetorically designated Arte Povera as 'notes for a guerrilla war'. It can, of course, be argued that all this is merely a gesture, a manifestation of radical chic, that the real force of Arte Povera lay in its technical radicalism with respect to materials and methods of construction. And yet it does undoubtedly point to the *socially* as well as artistically critical matrix of attitudes

that underlay much of the new art. The point, perhaps, is *not* to insist on separating the two aspects: that Arte Povera's enduring interest lies precisely in their combination.

LATIN AMERICA

Artists active in places where there actually was a guerrilla war going on found the situation tended to demand rather more directly political responses than those that sufficed for the radical avant-gardes in North America and Western Europe. Lucy Lippard dated her own politicisation from a trip to South America in November 1968 where she encountered a group of artists in Rosario working in conjunction with the Argentinian labour union, the CGT (*Confederación General del Trabajo*, or General Confederation of Labour). For historical reasons to do with the extremely constricted space for proper political debate, vanguard art in Latin America became a forum for cultural-political interventions. These ranged from the *Media-Art Manifesto*, published in Buenos Aires in July 1966, which promised to distribute misinformation about art in the mass media in order to underline the implication of art in publicity and news, to increasingly political demonstrations at major exhibitions such as the Córdoba Biennale. Though the term 'Conceptual art' was not employed to describe it until the 1970s, nonetheless this art has come to be positioned retrospectively as a key part of a 'global conceptualism'. In the words of Mari Carmen Ramirez, Latin American conceptualism was not a 'reflection, derivation or replica of centre-based conceptual art', but represented, rather, a series of 'local responses to the contradictions posed by the failure of post-World War II modernisation projects and the artistic models they fostered in the region'. Indeed, for Ramirez, this art was oriented from the start upon issues in the wider public sphere, rather than on the institution of (modernist) art itself, and as such may be said to have 'clearly anticipated' the political turn in metropolitan vanguard art during the 1970s.

The work that Lippard encountered in Rosario is a case in point. Since the mid-1960s, artists had been faced by an apparent failure of art institutions to address a situation of increasing political repression and censorship. This came to a head around events in the province of Tucamán, where government economic policies had resulted in mass unemployment and hardship. Conditions were exacerbated by the censorship of information in the mass media about conditions in the province. By 1968, about thirty artists were engaged on a joint project with the union to research and publicise conditions there. This work culminated in the exhibition *Tucamán Arde* (Tucamán Burns), installed in the CGT premises in Rosario. It has been described by Alex Alberro as 'an all-encompassing interior environment', in which visitors were confronted by a multi-media installation of text-based information in the form of slogans, leaflets and posters, as well as large-scale photographs and film

(fig.48). By simultaneously breaking with conventional assumptions about the legitimate contents of an art exhibition, as well as shifting out of the gallery and into a different kind of social institution, the participants sought to produce work that reflected the wider social reality in which art existed.

In Brazil, Cildo Meireles refunctioned the tradition of the readymade with his series, begun in 1969, of *Insertions into Ideological Circuits*. Meireles operated by withdrawing objects from systems of circulation, 'interfering' with them, and then putting them back into the system. One example consisted of rubber-stamping political messages on banknotes. The best known, however, was

48
Tucamán Arde
(Tucamán Burns) 1968

Multi-media installation, created at the CGT premises by artists and union workers in Tucamán, Argentina
Collection of Graciela Carnevale

49
Cildo Meireles

Insertions into Ideological Circuits: Coca-Cola Project 1970

Coca-Cola bottles with transferred text
18 (7⅛) high
Courtesy of the artist and Galerie Lelong, New York

cleverer in the way in which it achieved its effect. In the *Coca-Cola Project* of 1970, Meireles got hold of empty Coca-Cola bottles, Coca-Cola being perhaps *the* symbol of American consumer capitalism (fig.49). Onto these he silk-screened political messages in the same white ink as the bottles' normal printed 'Coca-Cola' symbol and brand information. As such, the messages remained more or less unnoticeable. However, Meireles then reintroduced the bottles into the system. They returned to the factory in the normal way, where they were washed and refilled. Once the brown liquid came to function as a background to the white lettering, the anti-imperialist message stood out.

SOVIET UNION

Unofficial artists in the Soviet Union had a different, but equally contradictory relationship to the Western avant-garde. Whereas in Latin America artists tended to be resistant to styles of art that were deemed to be representative of Western imperialism, unofficial artists in the Soviet bloc tended to embrace Western 'expressionist' individualism as part of their rejection of Socialist Realism. This did not change until the emergence of the 'Moscow Conceptualists' in the 1970s. Once again, the name was a retrospective label applied by the critic Boris Groys in 1979. Eric Bulatov and the Komar and Melamid duo developed a hybrid form of painting, based in equal parts on Soviet Socialist Realism and American Pop, to probe the representational conventions of official Soviet ideology. Ilya Kabakov adopted a different strategy owing more to developments in Western Conceptual art, mixed in with

50
Ilya Kabakov

Carrying out the Slop Pail 1980

Enamel on plywood
150 x 210
(59⅛ x 82¾)
Emanuel Hoffmann
Foundation, on
permanent loan to the
Museum of
Contemporary Art,
Basel

51
Mierle Laderman Ukeles

Washing Tracks/ Maintenance: Inside 1973

Photograph of
performance at
Wadsworth Atheneum,
Hartford, Connecticut
Courtesy Ronald
Feldman Fine Arts,
New York

52
Adrian Piper

Catalysis IV 1970–1

Street performance,
New York City

the experience of his official career as a children's book illustrator. In the early 1970s he produced a series of 'Albums', each of which was built around a fictional character, an artist. The device conferred an ability to represent different avant-gardist schools, as well as critical commentary upon them, within the scope of the work: an instance of a kind of second-order practice, encompassing and going beyond first-order vanguardist gambits, not least through the disruption brought to the conception of the 'authentic' authorial voice. The mix of image and text employed by Kabakov in the narrative albums was further developed in a series of larger paintings made in the later 1970s. These bore a resemblance to official notice boards, or bureaucratic forms blown up to a large scale. *Carrying out the Slop Pail* (fig.50) parodies the command

economy's obsession with planning by listing the rota for putting out the rubbish bins of a communal apartment for the next six years. During the *perestroika* of the 1980s, Kabakov began to be allowed to exhibit abroad, finally leaving the Soviet Union in 1989. Since then, his complex installations have been embraced into the pantheon of 'global conceptualism'. In one of culture's greater ironies, the figure who was marginalised for decades, perennially haunted by the prospect of being prevented from working by a hostile state bureaucracy, triumphantly represented Russia at the Venice Biennale of 1993. It remains an open question quite what this says about globalisation, the postmodernist cultural condition and a critical art practice; but it certainly says something.

USA

Back in the centre of the empire, by the start of the 1970s the world of art was beginning to be affected by the wider radicalism of the period. The Art Workers Coalition was formed in New York in January 1969 and rapidly came to embrace a portfolio of radical causes. The AWC's original concern had been only with artists' rights over the exhibition of their work, but this quickly grew to include involvement with the Anti-Vietnam war movement as well as a generalised criticism of racism and sexism, both within the art world and in society at large. In 1969, Mierle Laderman Ukeles composed the *Maintenance Art Manifesto*. In it she defined conventionally downgraded forms of labour most often associated with women, such as cooking, cleaning, shopping, etc., as 'maintenance'-type work, as distinct from more commonly acknowledged 'development'-type work, her argument being that the former type should be accorded equal status. In performances at the Wadsworth Atheneum, she scrubbed the floor and steps, polished display cases, and locked up the offices as examples of 'Maintenance art' (fig.51).

Among Conceptual artists, the work of Adrian Piper offers another example of the increasingly radical temper that was developing. In the late 1960s, she had produced typically self-referential language-based Conceptual art. But subsequently Piper turned to using her body, documenting, for example, what she was looking at, at a particular time, or participating in ordinary social situations such as walking down a street or riding on public transport while performing a series of unusual actions. In *Catalysis IV* she rode on the bus, but with a large white cloth protruding from her mouth (fig.52); in *Catalysis III* she went shopping to Macy's in clothes wet with paint. In 1970, Piper withdrew her proposed contribution to the New York Cultural Center exhibition *Conceptual Art and Conceptual Aspects*.

This was intended as a response to the worsening political situation in the country, as exemplified by the shooting of students at Kent State University who had been protesting at the escalation of the war in South-East Asia. Piper's letter of withdrawal was then incorporated into the notebooks constituting *Context #8* and *Context #9*, respectively subtitled 'Written Information Voluntarily Supplied to Me During the Period April 30 to May 30 1970' and 'Written Information Elicited From Me During the Period of May 15 to June 15, 1970'. Piper later referred to the development taking place in her work at that time as being 'from my body as a conceptually and spatio-temporally immediate art object to my person as a gendered and ethnically stereotyped art commodity'.

Sensation

Create a little sensation
Feel the difference that everyone can see
Something you can touch
Property
There's nothing to touch it

ContraDiction

You've got it
You want to keep it
Naturally. That's conservation
It conserves those who can't have it
They don't want to be conserved
Logically, that's contradiction

Logic

Everything you buy says something about you
Some things you buy say more than you realise
One thing you buy says everything
Property
Either you have it or you don't

UK

On the other side of the Atlantic, the analytical tenor of much British Conceptual art was being leavened by the influx of French theory in the early 1970s. 1967 had witnessed the English translation of Roland Barthes's *Elements of Semiology* as well as his influential essay on 'The Death of the Author'. His book of essays *Mythologies* belatedly appeared in English in 1972, containing his famous analysis of the different levels of meaning contained in a photograph, in particular the way in which a constructed image may set off unconscious chains of connotation in the viewer, the more so if the image appears entirely natural. For some time, 'critical' conceptualists had been moving towards an awareness of, not just art, but the broader register of 'the visual' in general as a major site of the social production, and reproduction, of meaning.

No one took ideology-critique and semiotics on board more comprehensively than Victor Burgin. In a series of works, he moved from general meditations on

the ideological functioning of visual imagery (fig.53) to specifically interventionist, consciousness-raising projects. Much of this work gained its impact through the unexpected conjunction of text and image, using all the persuasive devices of advertising. Thus a particularly glutinous image of a bourgeois family culled from an advertisement is forced into conjunction with a Maoist homily about subsuming one's individual desires for the greater good of the collective. Burgin went on to juxtapose photo-reportage-type images of low-paid female workers, or a poor mother pushing a pram through a desolate housing scheme, with upbeat captions from luxury adverts for perfumes, cars and the like. In one example from 1976, the images were printed as posters and pasted on sites around the city of Newcastle-upon-Tyne (fig.54 and frontispiece). The picture plays off a multiple contrast, between the image of the apparently well-off and beautiful embracing couple, the notion of

53
Victor Burgin

Sensation 1975

Photographic prints
and text
118 x 222 (46½ x 87⅜)
Private Collection,
London

54
Victor Burgin

Possession 1976

Poster
109 x 84 (43 x 33⅛)
Public Freehold
(photograph of work *in
situ*, Newcastle-upon-
Tyne)

'Possession' with its double suggestion of sexual domination and economic power, and the fact that a tiny minority of the population owns almost all the nation's wealth.

Art & Language played a complicated role in the politicisation of Conceptual art. In fact by the mid-1970s, Art & Language was far from a unified entity. In Britain, more than one generation was involved, and the younger ones were developing different interests and expectations from the original practice of 'Conceptual art'. In addition, the New York wing had become embroiled in a dispute with the English group that would eventually lead to its dissolution. From 1974, this group became involved in the production of *The Fox* (fig.55), a journal that briefly co-existed in a tense relationship with the original *Art-Language*. The title derived from a distinction drawn by Isaiah Berlin between 'the hedgehog', who knew 'one big thing', and

'the fox', who knew 'many small things'. Despite the fact that Berlin was addressing the contrasting merits of Leo Tolstoy and Fyodor Dostoevsky, the conceit might be seen to allegorise a difference between modernism (Greenberg: 'aesthetic value is one not many') and a Marxist approach attentive to the contingencies of a social practice in history. In terms of its published contents *The Fox* had a broader remit than *Art-Language*, as well as a more emphatically political tone. The following year, Terry Atkinson left the English group, initially working as a video artist, then turning to the production of drawings and paintings of explicitly political content on themes ranging from the First World War to the conflict in the north of Ireland. Those who remained functioned as a kind of grit in the art machine, maintaining an unremitting scepticism, both for the political enthusiasms of the New York group around *The Fox*, and to English artists and intellectuals whose politicised practice bore the stamp of French theory. English Art & Language viewed political conceptualism, indeed the wave of radicalised intellectual activity across the field of cultural studies, with suspicion, as representing social control by a new layer of cultural management rather than a genuinely transformational practice (fig.56).

55
The Fox, vol.1, no.1, 1975
Published in New York

56
Art & Language
from *Ten Posters* 1977
Silkscreen on paper
108 x 80
(42½ x 31½)

57
Combined Unions Against Racism / Gregor Cullen and Redback Graffix
The Workplace Is No Place for Racism 1985
Poster
Sydney

FOLLOWING DOUBLE PAGE:
58
Hans Haacke
Shapolsky et al. Manhattan Real Estate Holdings: A Real-Time Social System, as of May 1, 1971 (detail) 1971
Photographs and typewritten data sheets
Each photograph 50.8 x 19.1 (20 x 7½)
Courtesy of the artist

TRANSITIONAL PRACTICE

Out of this contested history emerged activities that were more akin to Ian Burn's sense of Conceptual art as 'transitional' (see p.54). Many were moving beyond the practice of art as such with its galleries, dealers and avowedly bourgeois social locale, into a more diffuse, harder-to-categorise realm of radical cultural practice, often working in conjunction with community groups, trade unions and so on. In the US, exiles from the disintegrated group around *The Fox*, including Michael Corris, Carole Condé, Karl Beveridge and others, set up *Red Herring*, another journal with an avowedly radical agenda, and working, in Corris's phrase, 'in the milieu of left and ultra-left "mass" organisations and Maoist "pre-party" formations'. In Edinburgh, Dave Rushton and myself, among others, continued with the *School* project by initiating the School Press. This worked to design and produce posters, leaflets and brochures for rank-and-file trade union groups, campaign organisations such as Rock Against Racism, and political bodies including the Socialist Workers Party. As New York Art & Language broke up, Ian Burn himself left the US and returned to Australia, partly encouraged by the potential opened up by the election of the socialist Whitlam government. Burn was active in Union Media Services, and

worked with Nigel Lendon, Terry Smith, Sandy Kirby and others on the Art and Working Life project. This also produced posters and brochures for a range of trade union and community groups (fig.57), as well as beginning to engage with specifically Australian issues such as the campaign for Aboriginal rights.

All of these initiatives arose directly out of forms of politicised Conceptual art, while those involved regarded themselves as having definitively broken with the practice of art as such, in the name of more practical forms of involvement with wider social constituencies. In his article 'Memoirs of an ex-conceptual artist' of 1981, Burn isolated five progressive features of Conceptual art: a reaction against the marketing system; a tendency to use more democratic forms of media and communication; a greater attention to actual human relationships; an emphasis on more collectively organised work methods; and an interest in education leading to a demystification of art and increased

awareness of art's role in the social system. He concluded: 'The real value of Conceptual Art lay in its transitional character, not in the style itself'.

INSTITUTIONAL CRITIQUE

That is, however, far from being the whole story. The politicisation of Conceptual art that we have just reviewed conformed to a relatively standard left-wing sense of the 'political'; a class politics of the New Left that had become dominant in the wake of the critique of Stalinism. However, the understanding of 'politics' itself was undergoing transformation during this period as questions of race and gender impacted on the traditional left-wing concern with class. Under the influence of such apparently diverse forces as the rise of feminism and the intensified presence of media technologies, it was as if art internally opened up to a range of new commitments and interests. Not

212 E 3 St.
Block 385 Lot 11
5 story walk-up old law tenement
Owned by Harpmel Realty Inc., 608 E 11 St., NYC
Contracts signed by Harry J. Shapolsky, President('63)
 Martin Shapolsky, President('64)
Principal Harry J. Shapolsky(according to Real Estate
Directory of Manhattan)
Acquired 8-21-1963 from John the Baptist Foundation,
c/o The Bank of New York, 48 Wall St., NYC,
for $237 600.- (also 7 other bldgs.)

$150 000.- mortgage at 6% interest, 8-19-1963, due
8-19-1968, held by The Ministers and Missionaries
Benefit Board of the American Baptist Convention,
475 Riverside Drive, NYC (also on 7 other bldgs.)

Assessed land value $25 000.-, total $75 000.- (includ-
ing 214-16 E 3 St.)(1971)

214 E 3 St.
Block 385 Lot 11
5 story walk-up old law tenement
Owned by Harpmel Realty Inc., 608 E 11 St., NYC
Contracts signed by Harry J. Shapolsky, President('63)
 Martin Shapolsky, President('64)
Principal Harry J. Shapolsky(according to Real Estate
Directory of Manhattan)
Acquired 8-21-1963 from John the Baptist Foundation,
c/o The Bank of New York, 48 Wall St., NYC,
for $237 600.- (also 7 other bldgs.)

$150 000.- mortgage at 6% interest, 8-19-1963, due
8-19-1968, held by The Ministers and Missionaries
Benefit Board of the American Baptist Convention,
475 Riverside Drive, NYC (also on 7 other bldgs.)

Assessed land value $25 000.-, total $75 000.- (includ-
ing 212 and 216 E 3 St.) (1971)

216 E 3 St.
Block 385 Lot 11
5 story walk-up old law tenement
Owned by Harpmel Realty Inc., 608 E 11 St., NYC
Contracts signed by Harry J. Shapolsky, President('6
 Martin Shapolsky, President('6
Principal Harry J. Shapolsky(according to Real Estate
Directory of Manhattan)
Acquired 8-21-1963 from John the Baptist Foundation,
c/o The Bank of New York, 48 Wall St., NYC
for $237 600.-(also 7 other bldgs.)

$150 000.- mortgage at 6% interest, 8-19-1963, due
8-19-1968, held by The Ministers and Missionaries
Benefit Board of the American Baptist Convention,
475 Riverside Drive, NYC (also on 7 other bldgs.)

Assessed land value $25 000.-, total $75 000.- (incl
ing 212-14 E 3 St.) (1971)

E 3 St.
ck 385 Lot 19
x 105' 5 story walk-up old law tenement

ed by Harpnol Realty Inc. 608 E 11 St. NYC
tracts signed by Harry J. Shapolsky, President('63)
 Martin Shapolsky, President('64)

uired from John The Baptist Foundation
 The Bank of New York, 48 Wall St. NYC
 $257 000.- (also 5 other properties) , 8-21-1963

O 000.- mortgage (also on 5 other properties) at 6%
erest as of 8-19-1963 due 8-19-1968

d by The Ministers and Missionaries Benefit Board of
 American Baptist Convention, 475 Riverside Dr. NYC

essed land value $8 000.- total $26 000.-(1971)

292 E 3 St.
Block 372 Lot 19
22 x 105' 5 story walk-up semi-fireproof apt. bldg.

Owned by Browein Realty Corp., 608 E 11 St., NYC
Contracts signed by Seymour Weinfeld, President
 Alfred Rayar, Vicepresident
Principal Harry J. Shapolsky(according to Real Estate
Directory of Manhattan)

Acquired 10-22-1965 from Apponaug Properties Inc.
475 Riverside Drive, NYC, Frank I.Taylor, President

$55 000.- mortgage at 6% interest, 10-22-1965, held by
The Ministers and Missionaries Benefit Board of The
American Baptist Convention, 475 Riverside Drive, NYC
(also on 312 E 3 St.)

Assessed land value $6 500.- , total $55 000.- (1971)

299 E 3 St.
Block 373 Lot 56
18 x 96' 5 story walk-up old law tenement

Owned by West No. 10 Realty Corp., 608 E 11 St., NYC
Contracts signed by Martin Shapolsky, Pres.('65)
 Donald Sherman, Pres.('68)
Principal Harry J. Shapolsky(according to Real Estate
Directory of Manhattan)

Acquired 3-11-1965 from 300 Realty Corp.,
608 E 11 St., NYC,
contracts signed by Harry J. Shapolsky, Pres.('66/67)
 Pearl Shapolsky, Pres.('64/65/67)
 Donald Sherman, Vicepres.('71)
Principal Harry J. Shapolsky(according to Real Estate
Directory of Manhattan)

$16 000.- mortgage, 11-27-1964, held through assignment,
8-30-1967, by 428 Realty Corp., 608 E 11 St., NYC,
contracts signed by Harry J. Shapolsky, Pres.('61/3/5/6),
due $8 875.29
$8 000.- due of mortgage held through assignment,7-30-1965,
by 428 Realty Corp.
$16 000.- mortgage, 3-12-1965, held by 428 Realty Corp.

Assessed land value $5 200.- , total $18 000.- (1971)

everyone felt they had to evacuate the territory of art to sustain a defensible critical practice.

A case in point is the work of Hans Haacke. In his earlier work, Haacke had moved from setting up kinetic systems for the circulation of liquids through tubes, or the continually repeated process of production and subsequent evaporation of condensation within a closed glass cube, to more open systems involving birds feeding and grass growing. By 1970 he had turned to social systems. As we have seen with Piper, the art world's response to the war in South-East Asia had been increasing, and on 22 May the New York Art Strike – organised by the Art Workers Coalition – involved picketing the Metropolitan Museum. As his contribution to the Museum of Modern Art's *Information* show that summer, Haacke installed a kind of voting booth consisting of two 'Yes' and 'No' boxes underneath a wall-mounted question: 'Would the fact that Governor Rockefeller has not denounced President Nixon's Indochina policy be a reason for you not to vote for him in November?'

Rockefeller was, of course, a luminary of the Museum as well as governor of New York. Two-thirds of those who took part in Haacke's poll voted 'Yes'.

Haacke's next planned show was to have been *Systems*, at the Guggenheim Museum, New York, in April 1971. The major new piece was to have been a photo-text documentation of what Haacke called *A Real-Time Social System*. This was to have consisted of the real estate holdings on Manhattan of 'Shapolsky et al.', slum landlords engaged in the exploitation of predominantly African-American and Puerto Rican communities (fig.58). The proposal elicited from the Guggenheim authorities a statement of what was considered to be the boundary of acceptability for a political dimension of art, a boundary that Haacke's work clearly overstepped. The museum director's statement acknowledged that 'art may have social and political consequences', but argued that these should be produced 'by indirection and by the generalised, exemplary force that works of art may exert upon the environment', and not, as Haacke proposed, 'by using political means to achieve political ends'. Haacke's deliberate blurring of the boundary between politics and art was simply too much for a culture whose official ideology of art centred around its independence, however much that supposed independence might be compromised by the status quo itself. The upshot was that the exhibition was foreclosed, its prospective curator dismissed, and Haacke became the figurehead of politicised Conceptual art.

Haacke got his own back in 1974 by producing a piece detailing the business

interests of the Guggenheim trustees. Since then, he has resolutely pursued a career of 'institutional critique', illuminating the political affiliations of the Saatchis, and other leading companies (fig.59). It is an open question whether this renders Haacke's practice an appropriately modernised form of enlightening Brechtian political criticism or a particularly astute way of having your cake and eating it. It is undeniable that the works mentioned here have now become canonical, residing in the collections of major museums. In the introductory material to his joint exhibition at the Serpentine Gallery and the Victoria & Albert Museum in London in 2001, Haacke is quite unproblematically described (by the very institutions he unmasks), as 'one of the most distinguished conceptual artists worldwide'. Bearing Ian Burn's comment in mind, one might reflect on there being no failure like complete success.

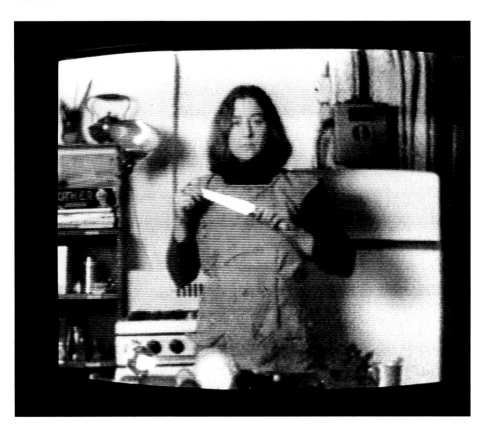

IDENTITY POLITICS

Others followed a similar trajectory, but tended to replace a sense of politics as concerning class and big business with the newly emergent identity politics, most notably in respect of issues of gender, sexuality and race/ethnicity. Martha Rosler, by her own account, responded to Michael Fried's criticism of 'theatricality' in art with an exclamation of 'Bingo! That's it'. The results can be seen in video works such as *Semiotics of the Kitchen* (fig.60). Standing in front of a kitchen table covered with utensils, Rosler goes through them alphabetically,

intoning their names and miming their use. By the end, however, she is brandishing the knife, acting out the frustrations of an identity confined by traditional gender-definition.

Among those who drove home the implications of a non-medium-specific Conceptual art for reflections on wider questions of representation and identity-construction was Mary Kelly. As well as building on both the social interventions of Haacke and the identity-related work of Piper, Kelly has commented on how she picked up on some of the potential of the Art & Language *Index* installations, or more particularly on what she saw as their *absences*: 'The significance of the relation between the psychic and the social was made obvious to me by its absence in Art & Language work ... I saw that space as being open.' Her *Post-Partum Document* (1973–9) remains a definitive statement on the interleaving of the psychic and the social. While she was working on it, however, Kelly was also involved in a more conventionally 'political' project

documenting the historical situation of women in the workforce. *Women at Work* (fig.61) by Margaret Harrison, Kay Fido Hunt and Kelly was an installation of photographs, documents and sound tapes comparable to the *Tucamán Burns* installation and the Australian Art & Working Life project. It occupied the border area between historical-political documentation (with its roots in the Mass Observation work of the 1930s) and a contemporary Conceptual art installation. This undecideablity is part of its character.

Kelly's *Post-Partum Document* likewise built on the presentational devices of conceptualism to produce a work that challenged conventional senses of the appearance and unity of the work of art (figs.62–3). Its subject was ostensibly very different from the world of industrial work, except that for Kelly the piece was very much about the sexual division of labour in society. The work is in six parts, consisting of over a hundred individual 'plaques' tracing her son's evolution from birth through to the acquisition of language and the ability to

61
Margaret Harrison, Kay Fido Hunt, Mary Kelly
Women at Work 1975
Installation at South London Gallery

62
Mary Kelly
One of eight individually framed panels from
Post-Partum Document (Documentation IV): Transitional objects, diary and diagram 1976
Collage, plaster of Paris and cotton with typed text
Panel size 27.9 x 35.6 (11 x 14)
Kunsthaus Zürich

63
Mary Kelly
One of thirteen individually framed panels from
Post-Partum Document (Documentation III): Analysed markings and diary-perspective schema 1975
Collage, pencil, crayon, chalk and printed diagrams on paper
Panel size 28.5 x 36 (11¼ x 14¼)
Tate

write his own name. The piece employs a wide range of signs – the child's scribble, footprints, stains and so on, but eschews iconic imagery. It also employs a variety of different texts: transcripts of the child's conversation, the mother's diaristic reflections on the situation, as well as examples of the psychoanalytic theory of Jacques Lacan that underwrites the project as a whole. This is a long way from the autonomous modernist work of art, a long way too from the 'analytic' Conceptual work reflecting self-referentially on the art condition. Kelly's documentation of the child/mother relationship consciously used the potential opened up by the new art to, as she put it, 'raise issues related to the social movements of the time'. Or perhaps more to the point, it began to place the 'social movements of the time' behind a more subjective range of issues to do with the construction of identity. In similar vein, Victor Burgin also moved away from failed agit-prop efforts like *Possession* to work on issues of sexuality, in *Zoo*, on popular culture and, in the case of *Office at Night*, on the implication of 'fine art' in constructions of gendered identity. By the early 1980s, artists like Burgin and Kelly now saw themselves as critically operating on a terrain of representation in general, a place where the visual, the conceptual and the political intersect. If Burn's *Art and Working Life* project embodied a left-wing move beyond art as such (Conceptual art included), *Post-Partum Document* was symptomatic of the shift from the politics of the New Left to the identity politics that came to permeate the postmodernist art of the last quarter of the twentieth century.

6

THE LEGACY

Various techniques and strategies associated with Conceptual art have become
pervasive in contemporary art. Jenny Holzer's employment of language is one.
Sherrie Levine's photographic critique of originality is another. Cindy
Sherman's play with identity is yet another. The use of text and photograph
made by Barbara Kruger is inconceivable without Conceptual art. And so on.
The work of many artists is underwritten by a politics of difference. That of
many others is focused on the social and institutional production of meaning.
These two strands have jointly rendered historical both the essentialism and the
autonomy-claims of modernist theory, no less comprehensively than
modernism itself once consigned the ethos of the academy to history
(although just as the ghost of classicism continued to haunt the modern
movement, the spectre of aesthetic value is present at the feast of
postmodernism). It would, however, be unfortunate to close a book on
Conceptual art with the implication that its principal legacy was one of an
ethically over-secure and humourless political correctness. On the other hand it
would be equally inappropriate to celebrate at face value the kind of claim we
have already encountered that 'Conceptualism has become all-pervasive if not
dominant in the art world'. In one sense perhaps it has. In response to
uncomprehending press criticism of his work, Damien Hirst remarked in 2000
that, 'I don't think the hand of the artist is important on any level because you
are trying to communicate an idea'. The 'idea' rather than the hand-crafted
object has become the common currency of international contemporary art.
But that art's relationship to its institutional context is far more secure than was

Conceptual art's at the moment of its emergence. Giant institutions such as Tate Modern, Guggenheim Bilbao, Temporary Contemporary, and others like them are monuments to the place contemporary art has come to occupy in the culture at large. The critic and broadcaster Matthew Collings locates the limit of this modishness when he recognises that 'the ideas are never important or even really ideas, more notions, like the notions in advertising'. Collings likes and admires contemporary art, because as he says 'it's just how life is today', a life that is preoccupied with questions such as: 'Will it make it? Will it fail? Will it get high prices? Will it be on TV?' Collings's love of the trivialities of contemporaneity, of art as the visual equivalent of pop music, is the other side of the coin from po-faced political correctness (and a lot easier to live with). But the point is that neither of them have much to do with the spirit that generated Conceptual art. As Bruce Nauman recognised, it wasn't at all clear what to do; and as Art & Language have said, it wasn't at all clear what the status of the result was.

At the beginning of this book, I argued that it was important to differentiate variant senses of our key term, 'conceptual'. There was an avant-gardist/Fluxus sense of the word suggesting a non-medium-specific range of activities, which, loosely speaking, went to ideas of a universal human creativity and of the world at large as the proper locale of art activity, rather than a specialised aesthetic practice. Then there was a self-conscious and more rigorously theorised 'Conceptual art', which emerged in the late 1960s. This was dedicated initially to a critical examination of the premises of both modernist and avant-gardist art, and evolved in the 1970s into a critical-political practice addressing a broad field of representation. This Conceptual art itself incorporated different strands, some more analytical and language-based, others closer to Fluxus activity in their incorporation of performance elements. These two aspects represented an interest in, respectively, mind and body. For many reasons, not least the rise of feminism, the last quarter of the twentieth century saw a decisive shift of interest on the part of artists to the body. Simultaneously, it became possible to sideline analysis and rational critique as hostage to a deeply unfashionable masculinism. The analytical strand of Conceptual art, linked as it was to a left-wing class politics, was eclipsed by a burgeoning of performance-related activities (often accompanied by video technologies or installations) and frequently underwritten by a politics of identity. This shift lies behind the emergence of the notion of 'conceptualism' that has come into currency to describe the range of object-, video-, performance- and installation-based activities that currently hold sway across the international art scene. 'Conceptualism' in this sense is effectively a synonym for 'postmodernism'. The edges between these different forms of activity are blurred, and it would be mistaken to enforce hard and fast distinctions or definitions. One can all too easily end up in the farcical situation of trying to apply a litmus test to discover whether Artist X, or indeed Artwork X, does or does not meet the residence qualification for its 'Conceptual' passport. That said, some distinctions, albeit provisional, are in order, lest everything sink into a morass where it is impossible to distinguish or evaluate interesting, critical and, dare one say it, progressive practices, from empty, mystificatory or self-publicising nonsense.

At any given time, most of the art that gets produced is not very interesting. This was as true of Conceptual art as it is of contemporary postmodernism, or as it was of academic art. In the past, natural wastage has taken care of that. But as the institution of art has become inflated in modern Western society, and as investment in it – both cultural and directly financial – has multiplied, it becomes less and less easy to tell when the Emperor is wearing his new clothes. Conceptual art's greatest strength is that it was, perhaps briefly, an episode against the grain of all this. Certain artists, *as artists*, took on the responsibility of checking over the kind of thing art was, the kind of institution it was, and the kind of role it fulfilled in modern society. It is, I feel, quite mistaken to conflate this kind of critical practice with the eclecticism that is the most noticeable feature of art at the turn of the twenty-first century. In some respects, Conceptual art may be responsible for this, for having broken down the barriers of the media out of which art is thought capable of being made. But in other senses it is not. I have mentioned the impact that T.S. Kuhn's theory of paradigm revolutions made on the development of Conceptual art. Kuhn argued that most of the time science progressed cumulatively, until anomalies built up and the whole structure was shaken up and a new period of normality commenced. The salient feature of most of the art to which the term 'conceptualism' is applied, whether positively or negatively, is that it is, so to speak, 'normal science'. It is the way things are now, just as academic art was in the middle of the nineteenth century and just as modernism was in the middle of the twentieth.

Hyperbole and utopianism aside, there is a sense in which Conceptual art *was* a form of guerrilla action against the powers that be, in the shape of institutionalised modernism in both the marketplace and the colleges where art was taught and reproduced. Mel Ramsden once remarked that Conceptual art was less about putting writing on the wall than it was about a spirit of scepticism and irony. If 'conceptualism' has indeed become the status quo of a bloated contemporary art world, then arguably it shares less with the spirit of historical Conceptual art than it does with the modern academy from which those artists took their distance. Nowadays, in a period of pervasive 'globalisation' we seem always to be hearing that 'we are all capitalists now' – *liberal* capitalists, of course. By the same token, culturally we are all supposed to be postmodernists. At the close of George Orwell's parable of frustrated revolution, *Animal Farm* (1945), the animals look through the windows of the house where their leaders, the pigs, are dining at the same table as the human farmers:

> As the animals outside gazed at the scene, it seemed to them that something strange was happening. What was it that had altered in the faces, what was it that seemed to be melting and changing? No question now, what had happened. The creatures outside looked from pig to man, and from man to pig, and from pig to man again; but it was already impossible to say which was which.

No doubt, critical art continues to be made. But only in an Orwellian sense can it be maintained that 'we are all conceptualists now'.

FURTHER READING

1965 to 1972 – when attitudes became form, exh. cat., Kettle's Yard, Cambridge 1984

Alberro, Alexander and Patricia Norvell (eds.), *Recording Conceptual Art*, Berkeley 2001

Alberro, Alexander and Blake Stimson (eds.), *Conceptual Art: A Critical Anthology*, Cambridge, Mass. 2000

Altshuler, Bruce, *The Avant-Garde in Exhibition*, Berkeley 1994

Baldwin, Michael, Charles Harrison and Mel Ramsden (eds.), *Art & Language in Practice*, 2 vols., Barcelona 1999

Buchloh, Benjamin, *Neo-avantgarde and Culture Industry*, Cambridge, Mass. 2000

Bürger, Peter, *Theory of the Avant-Garde*, trans. Michael Shaw, Minneapolis 1984

Burgin, Victor, *The End of Art Theory: Criticism and Postmodernity*, London 1986

Celant, Germano, *Art Povera: Conceptual, Actual or Impossible Art?*, Milan and London 1969

Christov-Bakargiev, Carolyn (ed.), *Arte Povera*, London 1999

Crow, Thomas, *Modern Art in the Common Culture*, New Haven and London 1996

Crow, Thomas, *The Rise of the Sixties*, London 1996

De Duve, Thierry, *Kant After Duchamp*, Cambridge, Mass. 1996

Documenta V, exh. cat., Kassel 1972

Documenta X, exh. cat., Kassel 1997

Foster, Hal (ed.), *Discussions in Contemporary Culture*, Seattle 1987

Fried, Michael, *Art and Objecthood*, Chicago 1998

Friedman, Ken (ed.), *The Fluxus Reader*, Chichester 1998

Global Conceptualism: Points of Origin 1950s–1980s, exh. cat., Queen's Museum of Art, New York 1999

Godfrey, Tony, *Conceptual Art*, London 1998

Goldstein, Ann and Anne Rorimer (eds.), *Reconsidering the Object of Art 1965–1975*, exh. cat., Musuem of Contemporary Art, Los Angeles 1996

Greenberg, Clement, *Art and Culture*, Boston 1961

Greenberg, Clement, *The Collected Essays and Criticism*, 4 vols., ed. John O'Brian, Chicago 1986–1993

Groys, Boris, David Ross and Iwona Blazwick (eds.), *Ilya Kabakov*, London 1998

Harrison, Charles, *Essays on Art & Language*, Oxford 1991

Harrison, Charles and Paul Wood (eds.), *Art in Theory 1900–1990*, Oxford 1992

Hopkins, David, *After Modern Art 1945–2000*, Oxford 2000

In the Spirit of Fluxus, exh. cat., Walker Art Centre, Minneapolis 1993

Kosuth, Joseph, *Art after Philosophy and After: Collected Writings 1966–1990*, Cambridge, Mass. and London 1991

Krauss, Rosalind, *The Originality of the Avant-Garde and Other Modernist Myths*, Cambridge, Mass. 1985

L'art conceptuel, exh. cat., Musée d'Art Moderne de la Ville de Paris 1989

Lippard, Lucy, *Six Years: The Dematerialization of the Art Object from 1966 to 1972*, 2nd ed., Berkeley 1997

Live in your Head: Concept and Experiment in England 1965–1975, exh. cat., Whitechapel Gallery, London 2000

Live in your Head: When Attitudes Become Form, exh. cat., Institute of Contemporary Arts, London 1969

Müller, Grégoire, *The New Avant-Garde: Issues for the Art of the Seventies*, London 1972

Newman, Michael and Jon Bird (eds.), *Rewriting Conceptual Art*, London 1999

Roberts, John (ed.), *The Impossible Document: Photography and Conceptual Art in Britain 1966–1976*, London 1997

Smithson, Robert, *The Collected Writings*, ed. Jack Flam, Berkeley 1996

Stiles, Kristine and Peter Selz (eds.), *Theories and Documents of Contemporary Art*, Berkeley 1996

Wallis, Brian (ed.), *Art After Modernism*, New York 1984

Wood, Paul (ed.), *The Challenge of the Avant-Garde*, New Haven and London 1999

Wood, Paul (ed.), *Modernism in Dispute: Art since the Forties*, New Haven and London 1993

INDEX

PHOTOGRAPHIC CREDITS

Orazio Bacci, Milan 21 (bottom); Robert Barry 3; The Anthony d'Offay Gallery 47; Kunstsammlung Nordrhein-Westfalen, Düsseldorf / photo Walter Klein, Düsseldorf 47, 58 (top); Charles Harrison 44 (top); The Menil Collection, Houston / photo Hickey-Robertson, Houston 8; The Metropolitan Museum of Art, New York © 1987 / photo Lynton Gardiner 30; The Museum of Contemporary Art, Los Angeles / photo Squids and Nunns 18 (left); Museum of Contemporary Art, San Diego, © 1966–8 John Baldessari / photo Philip Scholz Ritterman 32; © 2001 The Museum of Modern Art, New York 16, 18 (right), 34 (top); The Museum of Modern Art, San Francisco, photo Ben Blackwell 20; Oeffentliche Kunstsammlung, Basel / photo Martin Bühler 62; ©Yoko Ono / Lennono Photo Archive 22; © Edward Ruscha 1963 46; Seth Siegelaub / © 1969 Seth Siegelaub 38; photo © Fred Scruton 68–9

COPYRIGHT CREDITS

The publishers have made every effort to trace all the relevant copyright holders. We apologise for any omissions that might have been made.

Beuys, Broodthaers, Duchamp, Haacke, Kabakov, Manzoni: © DACS 2002

Buren, Magritte: © ADAGP, Paris and DACS, London 2002

Dibbets, Kosuth, LeWitt, Morris, Naumann, Weiner: © ARS, NY, and DACS, London 2002

Olitski: © DACS, London and VAGA, New York 2002

Rauschenberg: © Robert Rauschenberg / DACS, London and VAGA, New York 2002

Smithson: © Estate of Robert Smithson / VAGA, New York and DACS, London 2002